HOW TO DOODLE YEAR-ROUND

CUTE & SUPER EASY DRAWINGS
FOR HOLIDAYS, CELEBRATIONS AND SPECIAL EVENTS

KAMO

TUTTLE Publishing

Tokyo | Rutland, Vermont | Singapore

Contents

P a r t 4 Doodles for Fall

P a r t 5 Doodles for Winter

Let's Doodle

Hey, everyone, I'm Kamo, the author and illustrator of this book. Thanks for joining me as together we discover the joys of doodling the whole year round. The seasons—and the holidays, celebrations, observances and special events they contain—are a perfect excuse to use doodles to dress up your notebooks, cards, letters, invitations and anything else you wish to add that special touch to.

This book contains a wealth of doodle suggestions, divided by season, to add to your personal items and messages. Start with these, then create your own!

The most important thing about doodling is that it is simple, easy to do and easy to understand. As you work through the book, picking up various drawing tricks and techniques and referring to the steps and stages along the way, your doodles will take on detail and character. In other words, they'll be an expression of you! I've scattered key points throughout. They're marked in red , so use them as a reference when you're first starting out.

Don't forget to highlight and showcase your individual doodling style as it develops. When you're ready to personalize an illustration, to add your own unique embellishments or if you just want to go off in a design direction all your own, keep an eye out for the blue markers ◣ throughout the book. They show you parts of a drawing you can change as you see fit. Doodling is about improvzation, so be open to the changes and improvizations.

Doodle with confidence, let your hand flow freely across the page, looping and swirling, and you never know what amazing illustrations will appear before you.

Happy doodling,
— Kamo

The basics

Part 1

How to Draw with a Pen

Let's start with the basics: How do I use my pen?
Once you've mastered how to draw lines, apply
color and create color schemes, you'll soon be off
and doodling. So let's start practicing.

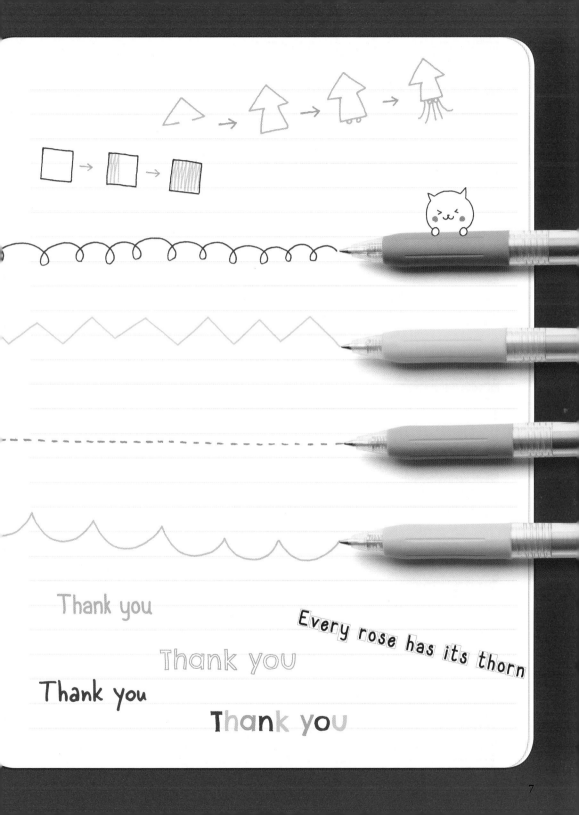

Thank you

Thank you

Thank you

Thank you

Every rose has its thorn

How to use this book

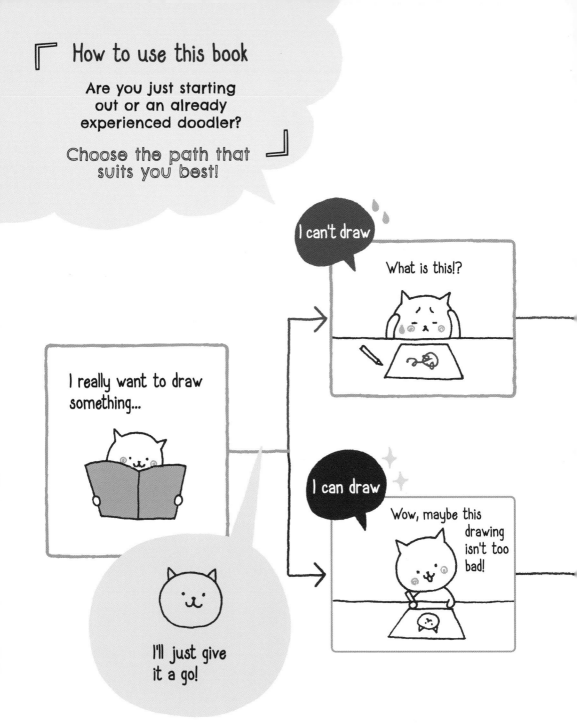

Are you just starting out or an already experienced doodler?

Choose the path that suits you best!

I really want to draw something...

I'll just give it a go!

I can't draw

What is this!?

I can draw

Wow, maybe this drawing isn't too bad!

There are all kinds of ballpoint pens

copying tip

Look out for the red icon on each page and make use of it when drawing!

Copy the illustrations in this book by tracing over them

♪

I did it!

tweaking tip

Try altering the illustration a bit too

use different colors

change the pattern

I'll try a seasonal illustration!

There are illustrations for all seasons from page 32 on! Use whichever ones work for the event you're drawing.

9

First, try drawing with a ballpoint pen

Before you draw lines or write letters and numbers with a ballpoint pen, read through these basic points. Then pick up that pen and get drawing!

I want to draw!

Cherish that feeling...

Grab hold of the pen

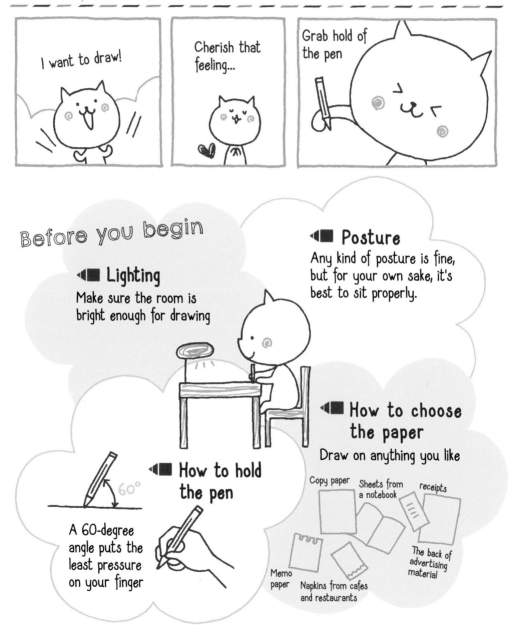

Before you begin

Lighting
Make sure the room is bright enough for drawing

Posture
Any kind of posture is fine, but for your own sake, it's best to sit properly.

How to hold the pen
60°

A 60-degree angle puts the least pressure on your finger

How to choose the paper
Draw on anything you like

Copy paper Sheets from a notebook receipts

Memo paper Napkins from cafes and restaurants

The back of advertising material

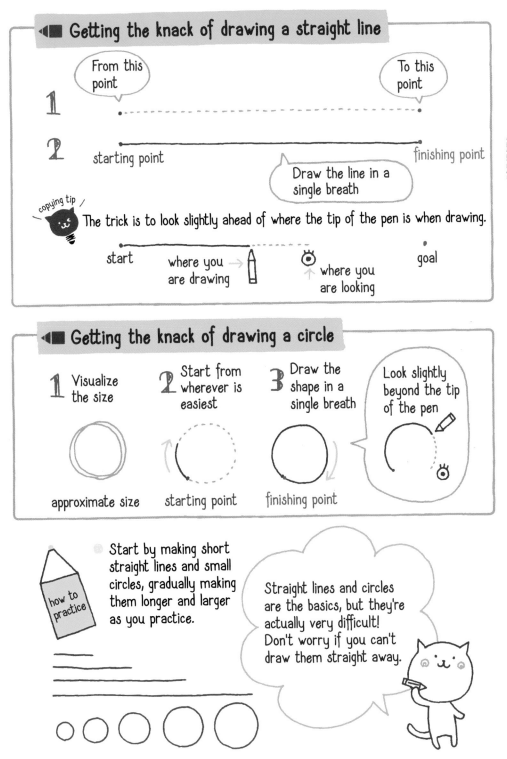

Getting the knack of drawing a straight line

1

From this point

To this point

2

starting point

Draw the line in a single breath

finishing point

copying tip

The trick is to look slightly ahead of where the tip of the pen is when drawing.

start

where you are drawing

where you are looking

goal

Getting the knack of drawing a circle

1 Visualize the size

2 Start from wherever is easiest

3 Draw the shape in a single breath

Look slightly beyond the tip of the pen

approximate size

starting point

finishing point

how to practice

Start by making short straight lines and small circles, gradually making them longer and larger as you practice.

Straight lines and circles are the basics, but they're actually very difficult! Don't worry if you can't draw them straight away.

11

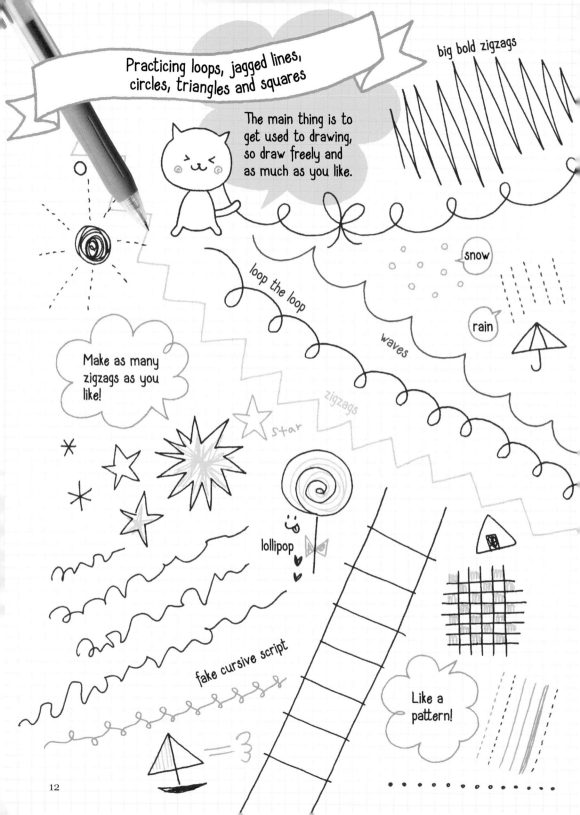

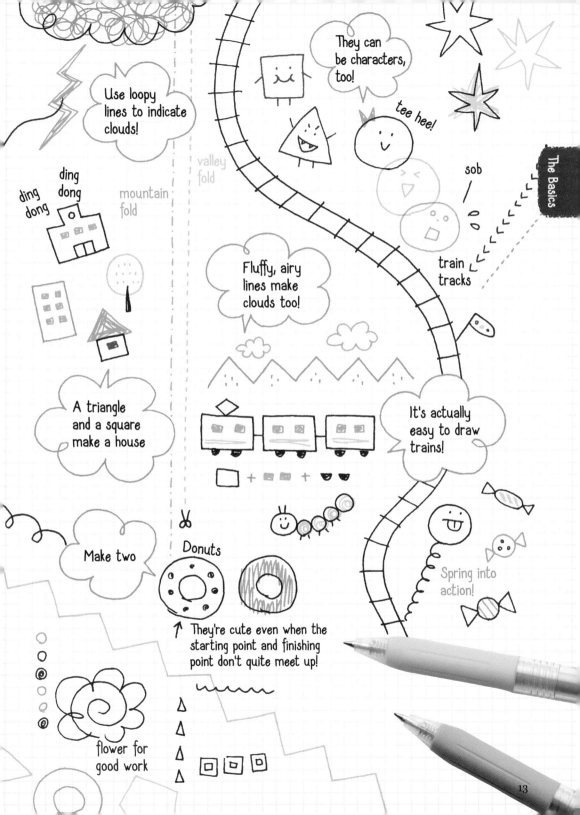

Let's practice various ways of applying color

The way color is added to a doodle can completely change it. Look over these various ways of adding highlighting hues or the pop of color to your illustrations.

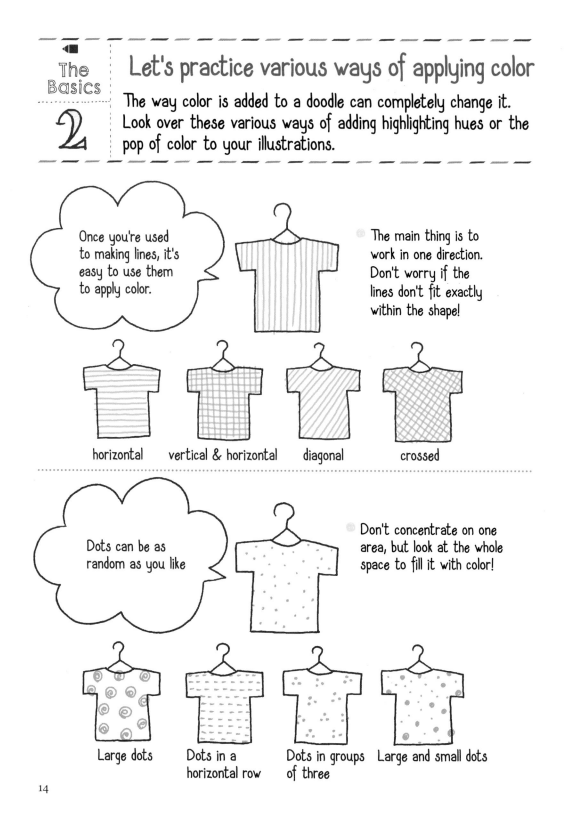

Once you're used to making lines, it's easy to use them to apply color.

The main thing is to work in one direction. Don't worry if the lines don't fit exactly within the shape!

horizontal vertical & horizontal diagonal crossed

Dots can be as random as you like

Don't concentrate on one area, but look at the whole space to fill it with color!

Large dots Dots in a horizontal row Dots in groups of three Large and small dots

◀■ Color to fit the shape

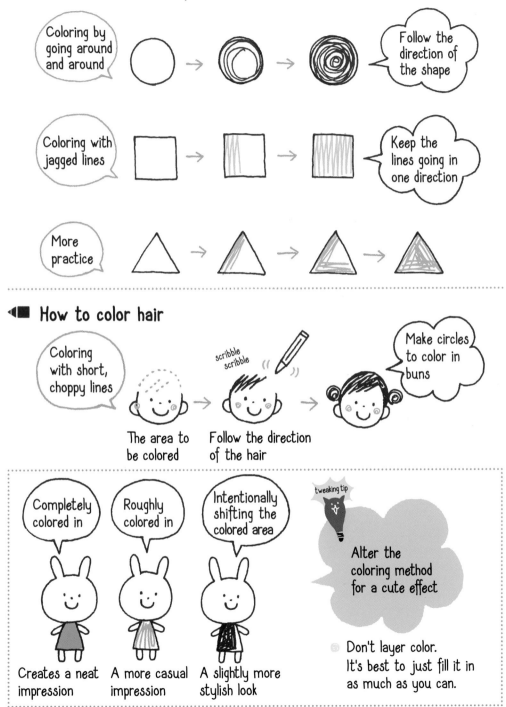

Coloring by going around and around → → **Follow the direction of the shape**

Coloring with jagged lines → → **Keep the lines going in one direction**

More practice → → →

◀■ How to color hair

Coloring with short, choppy lines

scribble scribble

Make circles to color in buns

The area to be colored

Follow the direction of the hair

Completely colored in

Roughly colored in

Intentionally shifting the colored area

tweaking tip

Alter the coloring method for a cute effect

Creates a neat impression

A more casual impression

A slightly more stylish look

● Don't layer color. It's best to just fill it in as much as you can.

Learn the basics of color coordination

Coordinating colors is another way to set your illustrations apart. Play with different combinations until you've found the right look.

Main color	Characteristics etc	Color 1	Color 1 + color 2	Color 1 + color 2 + color 3
●	Easy to use as the main line in a drawing. Creates a chic impression when applied as color.			
●	Use for a low-key look. Goes with any other color.			
●	Makes for a stylish look. Even used alone, it creates a strong impression.			
●	A color with a neat, clean feel. Stands out even when used alone.			
●	Fresh and cool. Use with cool tones to create a stronger impression.			
●	A natural color that stands out even when used on its own.			
●	A color that works for people of all ages. It is not as strong as green and makes for a softer look.			
●	Doesn't stand out as much as other colors. Use when adding just a touch of color.			
●	A color that works for people of all ages. A go-to when you're not sure what color to use.			
●	Tends to make a feminine impression. Creates a pop-art vibe.			
●	Bright and warm, it works surprisingly well with any other color.			
●	Elegant and enchanting, this is quite a difficult color to combine with others but looks stylish when it works.			
●	Easy to use as the main line in a drawing. Makes a softer impression than black.			

* These are my impressions of these colors as they appear in ballpoint pen. Please use them simply as a reference.

Copying

When you find an illustration you like →

it's the perfect opportunity to copy it. ♪ →

Copy the good parts, the parts you like as much as you can!

Tips

1. Look carefully

View it from various angles

Observe the object so that, in your head, you can rotate it around completely

2. Have confidence

Don't worry that the drawing doesn't look like the object or that things are sticking out in the wrong places!

What you draw is right!

3. Don't overthink things

Really?

That's so cute!

Your drawing is a lot better than you think

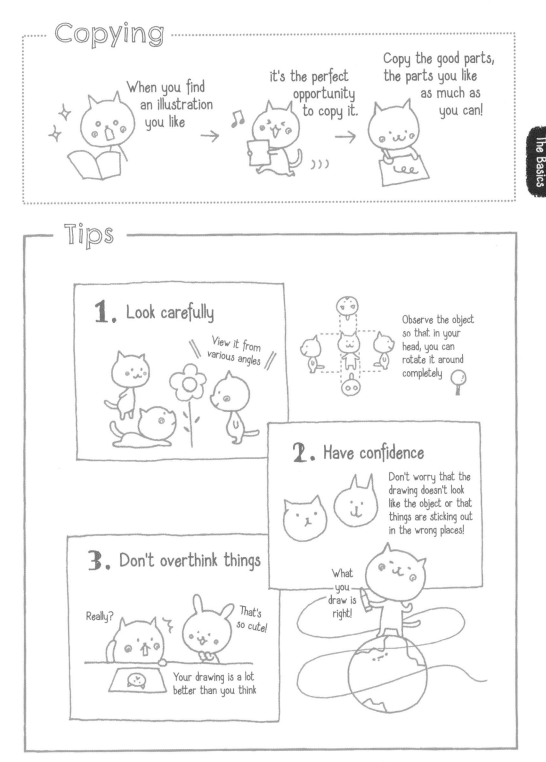

17

Learn the basics for drawing body parts in order to create caricatures

Drawing human figures can be hard!! Make boisterous boys full of life by using straight lines, and use curved lines for demure girls. Keep the character's personality in mind too.

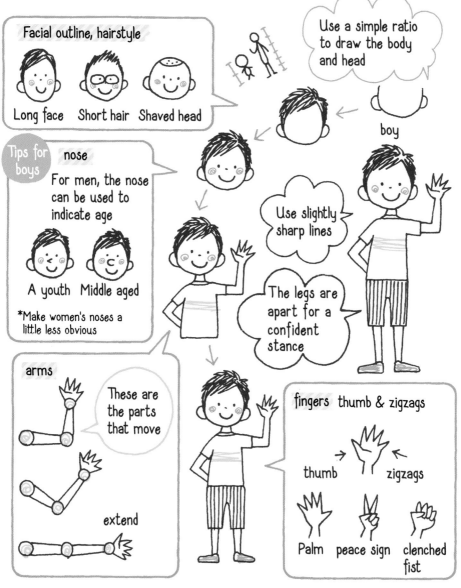

Facial outline, hairstyle

Long face Short hair Shaved head

Use a simple ratio to draw the body and head

boy

Tips for boys

nose

For men, the nose can be used to indicate age

A youth Middle aged

*Make women's noses a little less obvious

Use slightly sharp lines

The legs are apart for a confident stance

arms

These are the parts that move

extend

fingers thumb & zigzags

thumb zigzags

Palm peace sign clenched fist

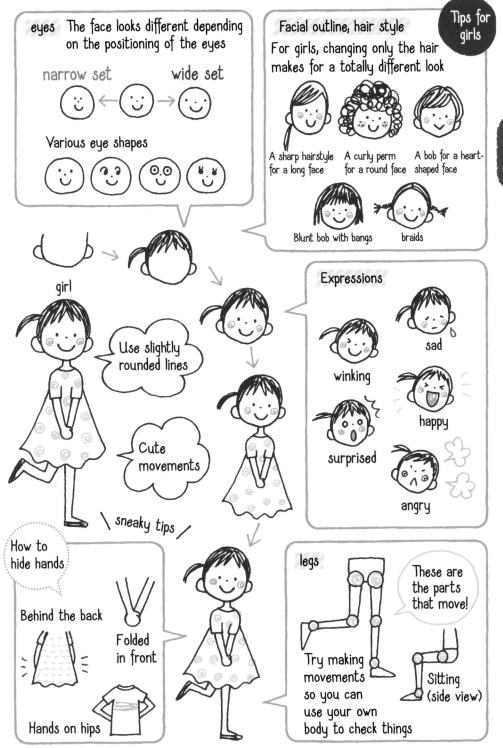

eyes The face looks different depending on the positioning of the eyes

narrow set → wide set

Various eye shapes

Facial outline, hair style

For girls, changing only the hair makes for a totally different look

A sharp hairstyle for a long face

A curly perm for a round face

A bob for a heart-shaped face

Blunt bob with bangs

braids

girl

Use slightly rounded lines

Cute movements

\ sneaky tips /

Expressions

winking

sad

surprised

happy

angry

How to hide hands

Behind the back

Folded in front

Hands on hips

legs

These are the parts that move!

Try making movements so you can use your own body to check things

Sitting (side view)

Combine the face and body of animals for cute, comical effects

Most animals start with the same basic shapes, so add ears to a round face or a tail to the round rear end to create different animals. Once you've got the hang of drawing four-legged animals, you'll find it's really quite simple.

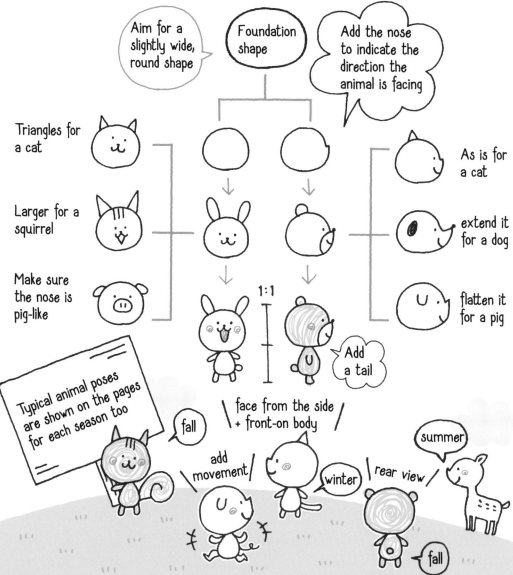

Aim for a slightly wide, round shape

Foundation shape

Add the nose to indicate the direction the animal is facing

Triangles for a cat

Larger for a squirrel

Make sure the nose is pig-like

1:1

Add a tail

As is for a cat

extend it for a dog

flatten it for a pig

Typical animal poses are shown on the pages for each season too

fall

face from the side + front-on body

add movement

winter

rear view

summer

fall

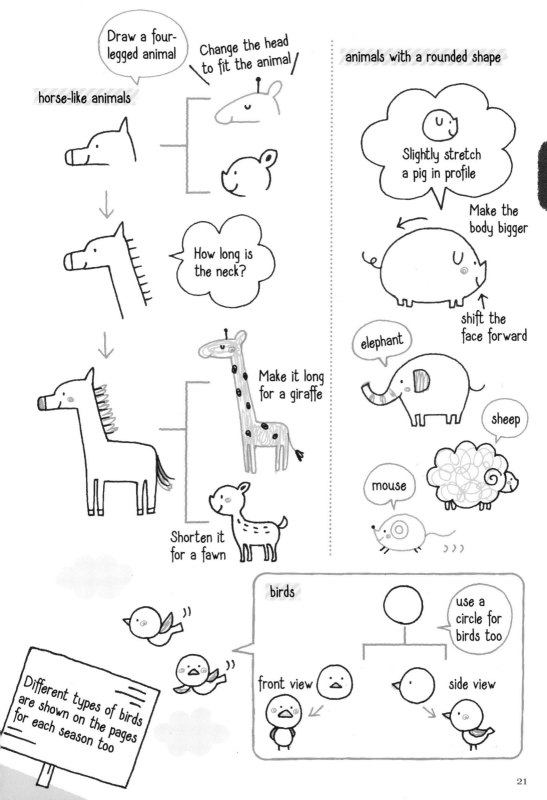

21

Make changes to the basic structure to create insects and marine creatures

NO.

03·04

Level

Insects are made up of a head, thorax and abdomen, while fish typically have a long, thin body and a tail. Add color and decoration to bring out individual characteristics, using the sample illustrations as a reference.

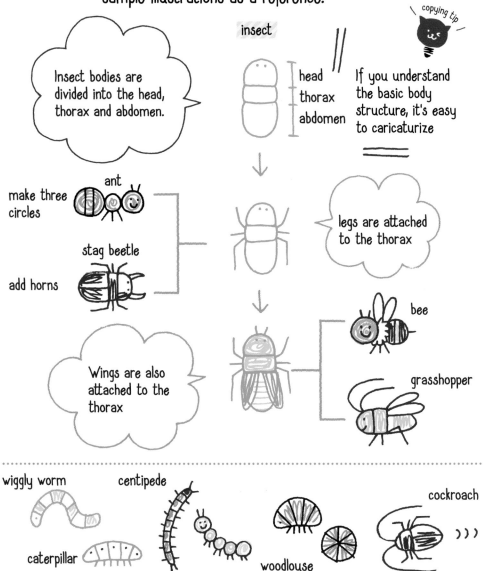

copying tip

insect

Insect bodies are divided into the head, thorax and abdomen.

head
thorax
abdomen

If you understand the basic body structure, it's easy to caricaturize

ant

make three circles

legs are attached to the thorax

stag beetle

add horns

bee

Wings are also attached to the thorax

grasshopper

wiggly worm

centipede

cockroach

caterpillar

woodlouse

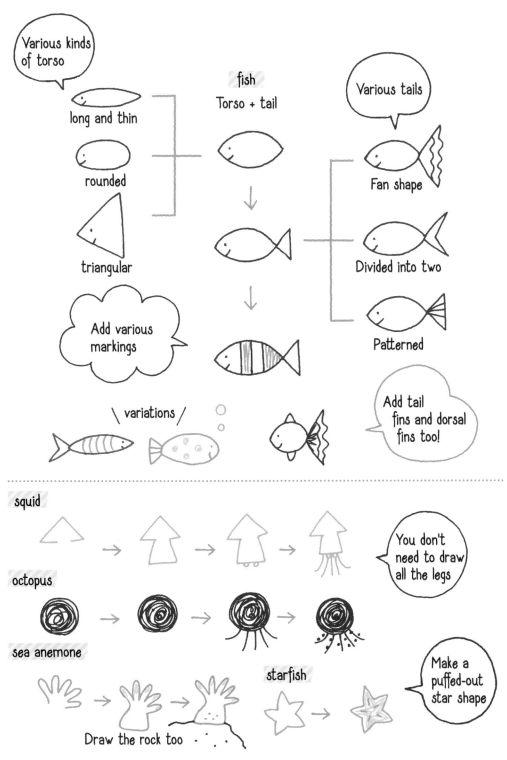

Various kinds of torso

long and thin

rounded

triangular

Add various markings

\ variations /

fish

Torso + tail

Various tails

Fan shape

Divided into two

Patterned

Add tail fins and dorsal fins too!

squid

You don't need to draw all the legs

octopus

sea anemone

Draw the rock too

starfish

Make a puffed-out star shape

Create simple designs and color schemes for plants and flowers

For flowers and plants, simplify the main elements, then fill in the colorful bloom and the rest however you like. Decorate the edges of message cards with flowers to add that extra touch of cheer!

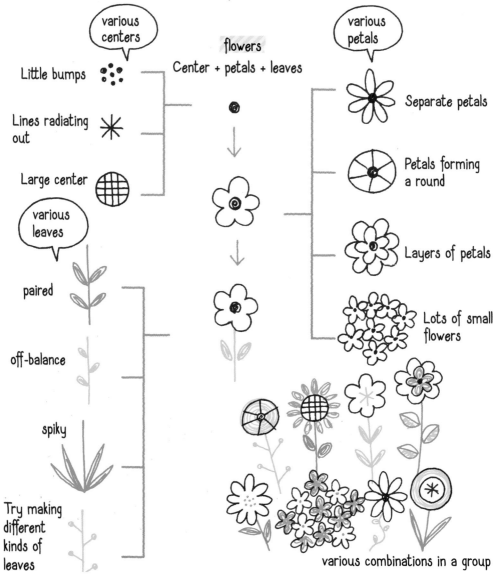

various centers

flowers
Center + petals + leaves

various petals

Little bumps

Lines radiating out

Large center

various leaves

paired

off-balance

spiky

Try making different kinds of leaves

Separate petals

Petals forming a round

Layers of petals

Lots of small flowers

various combinations in a group

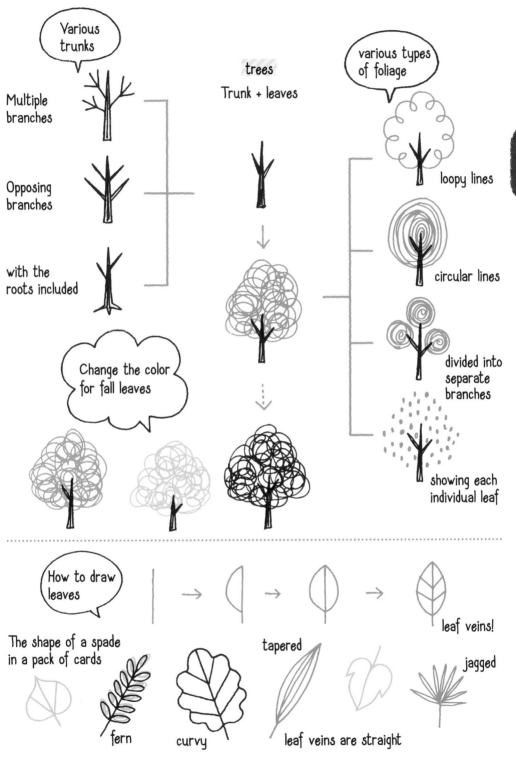

Various trunks

Multiple branches

Opposing branches

with the roots included

trees
Trunk + leaves

various types of foliage

loopy lines

circular lines

divided into separate branches

showing each individual leaf

Change the color for fall leaves

How to draw leaves

leaf veins!

The shape of a spade in a pack of cards

tapered

jagged

fern

curvy

leaf veins are straight

25

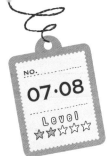

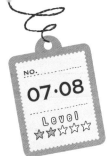
NO.
07·08
Level
★★☆☆☆

The angles are important when drawing food and other small items

Making snacks and other foods look realistic is harder than it looks! Rather than drawing them from the front, experiment by doodling them from the side, diagonally or from another off-kilter viewpoint.

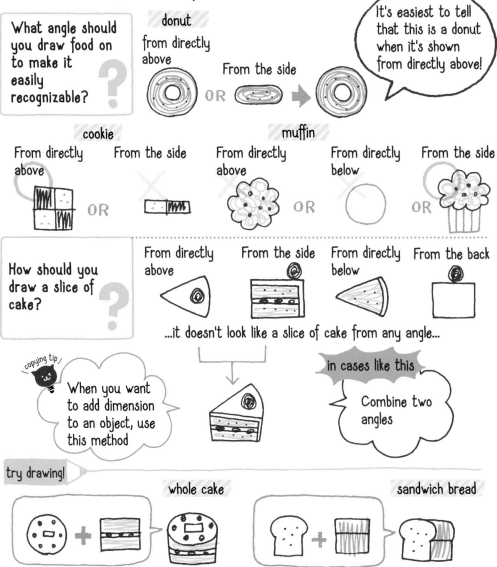

What angle should you draw food on to make it easily recognizable?

donut

from directly above

From the side

OR

It's easiest to tell that this is a donut when it's shown from directly above!

cookie

From directly above

From the side

OR

muffin

From directly above

From directly below

From the side

OR

OR

How should you draw a slice of cake?

From directly above

From the side

From directly below

From the back

...it doesn't look like a slice of cake from any angle...

copying tip

When you want to add dimension to an object, use this method

in cases like this

Combine two angles

try drawing!

whole cake

+

sandwich bread

+

26

cutlery

Draw cutlery on an angle so that it's easily recognizable, too

fork knife whisk spatula

chopsticks

spoon butter knife

tweaking tip

wooden bring out textures Aluminum ladle

Draw the grain of the wood

Make it look shiny

mug pot

Craft utensils

Bring out the cute shapes that characterize craft utensils

scissors spray bottle pincushion

The key is to draw pins sticking out of the cushion

iron sewing mannequin

bobbin / pincushion thread

Sewing machine

Use dots to indicate measurement units

Sewing thread

Tape measure ruler

27

Create icons and symbols and give ruled lines a pop art look

Various symbols and signs come to life and command extra attention when they're hand drawn. To add a decorative touch, use lines and design motifs to frame your doodles.

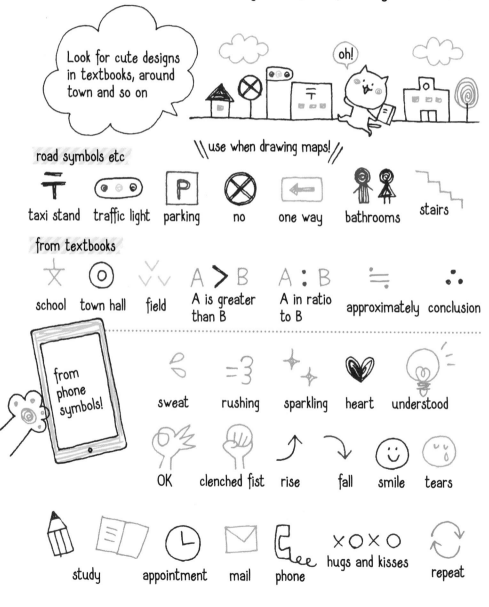

Look for cute designs in textbooks, around town and so on

oh!

road symbols etc

\\ use when drawing maps! //

taxi stand traffic light parking no one way bathrooms stairs

from textbooks

school town hall field A is greater than B A in ratio to B approximately conclusion

from phone symbols!

sweat rushing sparkling heart understood

OK clenched fist rise fall smile tears

study appointment mail phone hugs and kisses repeat

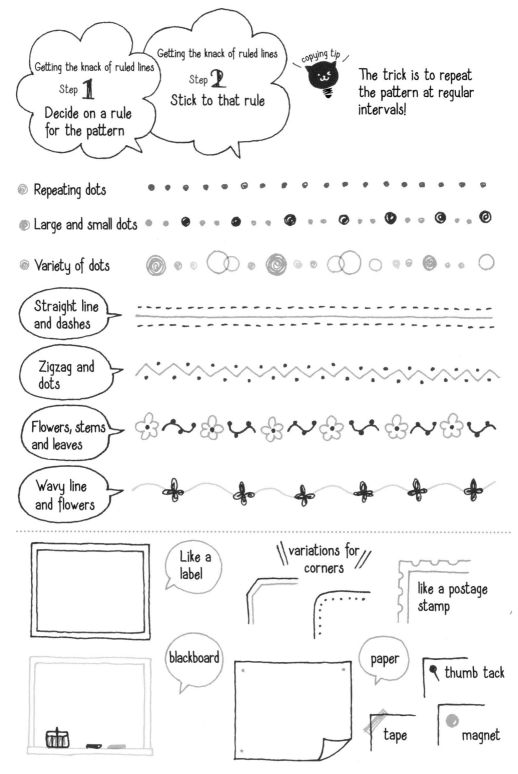

Getting the knack of ruled lines

Step **1**

Decide on a rule for the pattern

Getting the knack of ruled lines

Step **2**

Stick to that rule

copying tip

The trick is to repeat the pattern at regular intervals!

◎ Repeating dots

◎ Large and small dots

◎ Variety of dots

Straight line and dashes

Zigzag and dots

Flowers, stems and leaves

Wavy line and flowers

Like a label

variations for corners

like a postage stamp

blackboard

paper

thumb tack

tape

magnet

Use playful flourishes to make your letters bold and distinctive

Don't restrict your doodles to just objects and people, embellish letters, script and alphabetic symbols as well. Consider the meanings of the words you're using as you create designs to complement them.

Tip 1

Form letters so that they fit into evenly spaced boxes.

花 に 嵐 の 例 え も あ る さ

Remove the boxes, and this is the result...

花 に 嵐 の 例 え も あ る さ

...it's a bit off balance...

Alter the size of the characters for visual variety.

花 に 嵐 の 例 え も あ る さ

花 に 嵐 の 例 え も あ る さ

Try doodling Chinese and Japanese characters, playing with the sizes and shapes

Tip 2

✕ また明日 ◯ また明日

↑ See you tomorrow

The horizontal line is all over the place

↑ See you tomorrow

The horizontal line is straight

Slightly raising the characters at their top right makes for a mature look

Letters are part of the illustration, so they work effectively if you match them to the mood of the drawing

See you tomorrow

every rose has its thorn

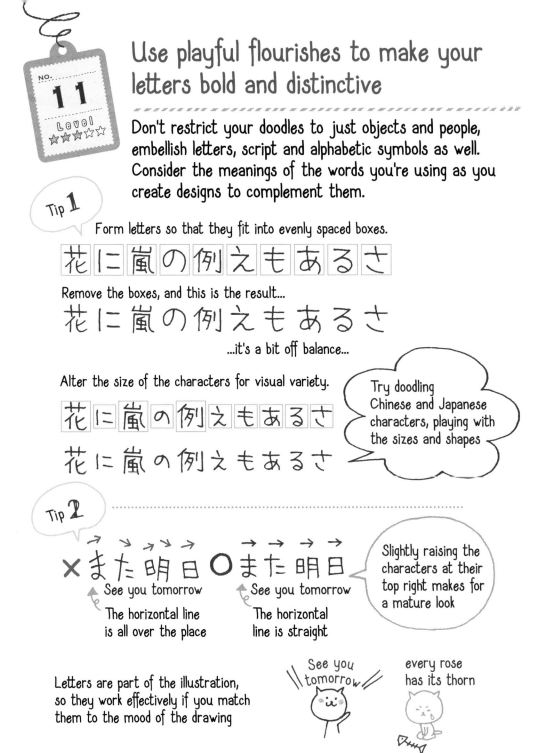

Decorate letters as you would ruled lines

1 Decide on a rule for decorating letters

2 Stick to that rule

ありがとう ← Thicken vertical strokes

ありがとう ← Add dots at ends

ありがとう ← White version

ありがとう ← Add bars at ends

ありがとう ← Add triangles at ends

ありがとう ← Use dots

ありがとう ← Hollow letters

ありがとう ← Double strokes

ありがとう ← Drop shadow

ありがとう ← Brushstroke style

ありがとう ← Different colors for each stroke

ありがとう ← Place inside circles

ありがとう ← Place inside bunting

‖ありがとう‖ ← Add effect

ありが♪とう♪ ← Insert musical symbols

ありがとう ← Add an accent

ありがとう ← Place in a speech bubble

31

Spring

Doodles for Spring

It's time to sketch the seasons, starting with the rebirth of spring. Try to incorporate the feeling of vitality and the anticipation of new life into your drawings, especially through the gentle use of color to bring out an air of softness.

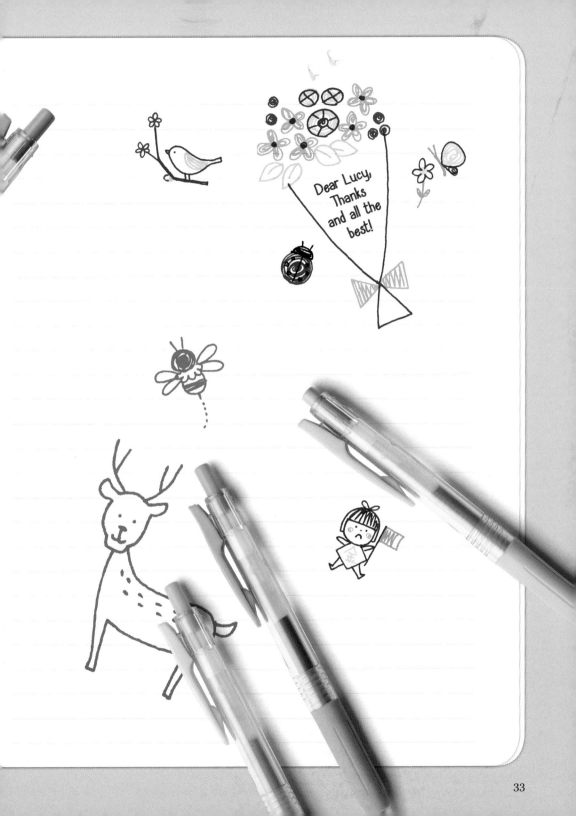

Dear Lucy,
Thanks
and all the
best!

Give your gear a makeover

Spring

Spring is the time to renew, refresh, reinvigorate. Give your favorite things a whole new look by decorating them with cute icon-style drawings.

Crayon set

Mark each crayon in a set with its color name and accompanying icon or symbol. Add illustrations to liven up the lid of the box as well.

Gel ballpoint pens

These types of pens color beautifully, as they combine the advantages of oil-based and water-based inks.

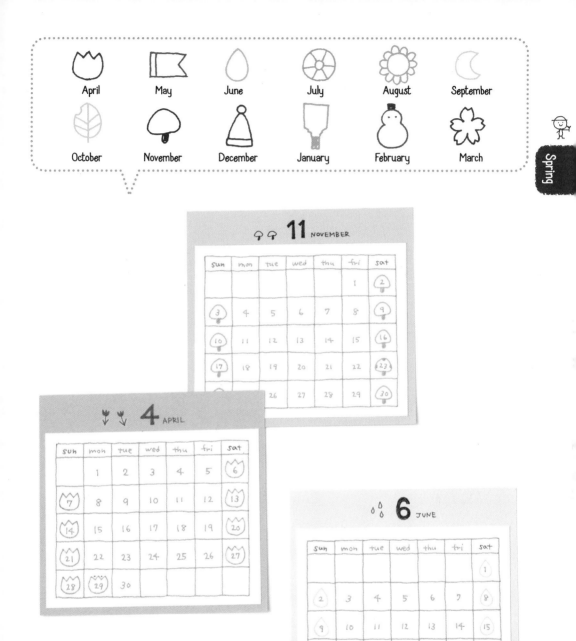

April	May	June	July	August	September
October	November	December	January	February	March

🍄🍄 11 NOVEMBER

sun	mon	tue	wed	thu	fri	sat
					1	2
3	4	5	6	7	8	9
10	11	12	13	14	15	16
17	18	19	20	21	22	23
	26	27	28	29		30

🌷🌷 4 APRIL

sun	mon	tue	wed	thu	fri	sat
	1	2	3	4	5	6
7	8	9	10	11	12	13
14	15	16	17	18	19	20
21	22	23	24	25	26	27
28	29	30				

💧💧 6 JUNE

sun	mon	tue	wed	thu	fri	sat
						1
2	3	4	5	6	7	8
9	10	11	12	13	14	15
16	17	18	19	20	21	22
23/30	24	25	26	27	28	29

Calendar

Decorate a calendar with illustrations for each month of the year. Add symbols for Saturday and Sunday or to indicate special days.

Use spring colors to enhance blooms and blossoms

April showers bring May flowers. Spring means buds, blooms and blossoms. Here the focus is on cherry blossoms, but choose any spring flower you want to doodle. Dress up an invitation with items you associate with the season.

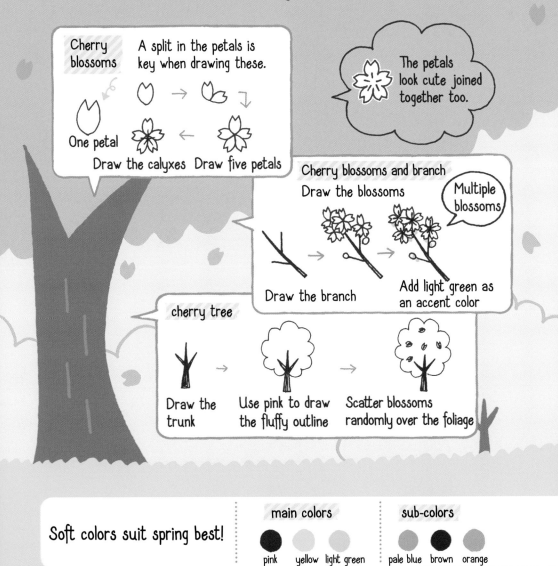

Cherry blossoms A split in the petals is key when drawing these.

One petal

Draw the calyxes Draw five petals

The petals look cute joined together too.

Cherry blossoms and branch
Draw the blossoms

Multiple blossoms

Draw the branch

Add light green as an accent color

cherry tree

Draw the trunk

Use pink to draw the fluffy outline

Scatter blossoms randomly over the foliage

Soft colors suit spring best!

main colors

pink yellow light green

sub-colors

pale blue brown orange

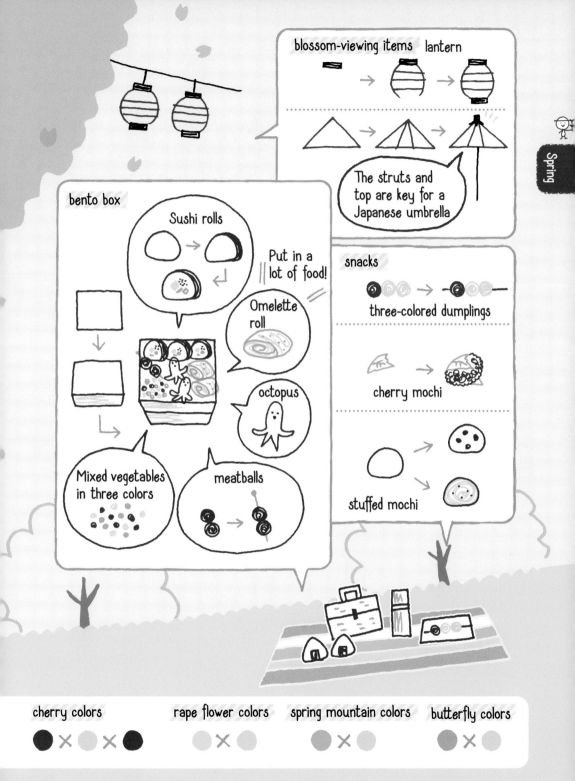

blossom-viewing items lantern

The struts and top are key for a Japanese umbrella

bento box

Sushi rolls

Put in a lot of food!

Omelette roll

octopus

Mixed vegetables in three colors

meatballs

snacks

three-colored dumplings

cherry mochi

stuffed mochi

cherry colors

rape flower colors

spring mountain colors

butterfly colors

Use bright colors to create a range of spring plants

Spring blooms make great doodles. Add them to cards, messages and invitations. Save the carnations and bouquets for Mother's Day cards.

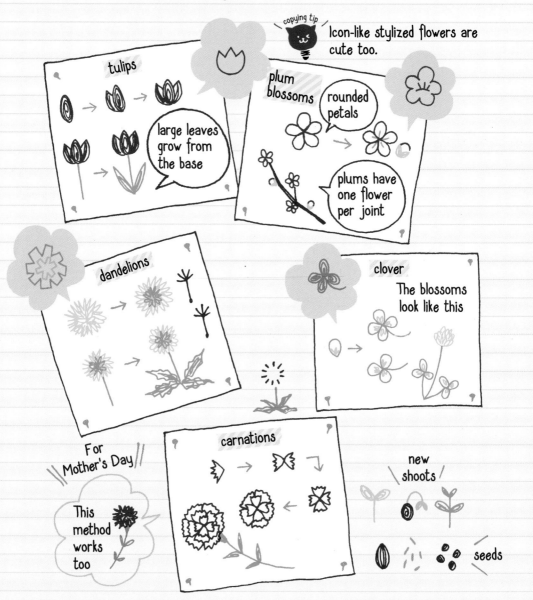

copying tip

Icon-like stylized flowers are cute too.

tulips

large leaves grow from the base

plum blossoms

rounded petals

plums have one flower per joint

dandelions

clover

The blossoms look like this

For Mother's Day

This method works too

carnations

new shoots

seeds

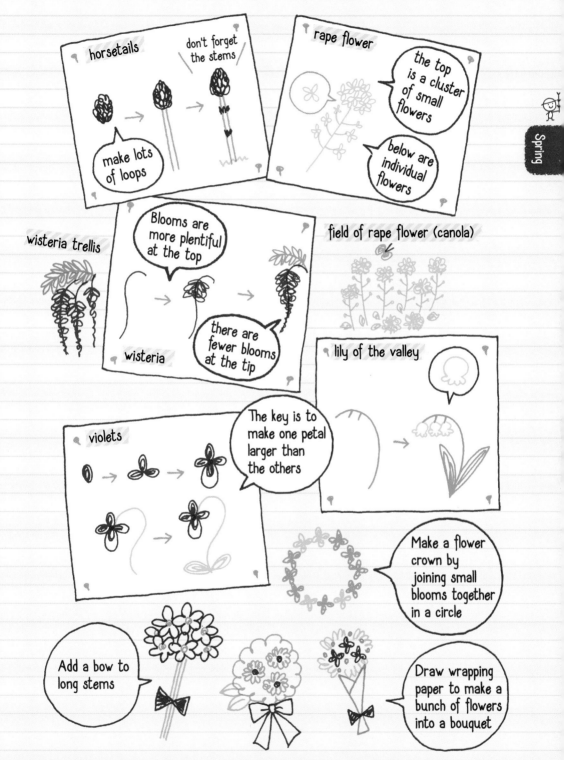

39

Bring spring creatures to life with the use of soft colors

NO.
14
Level
★★☆☆☆

Spring means the return of birds. Add your favorite winged creatures to diaries, notepads and journals. Or try a different spring animal. Gentle tones evoke the feel of the season.

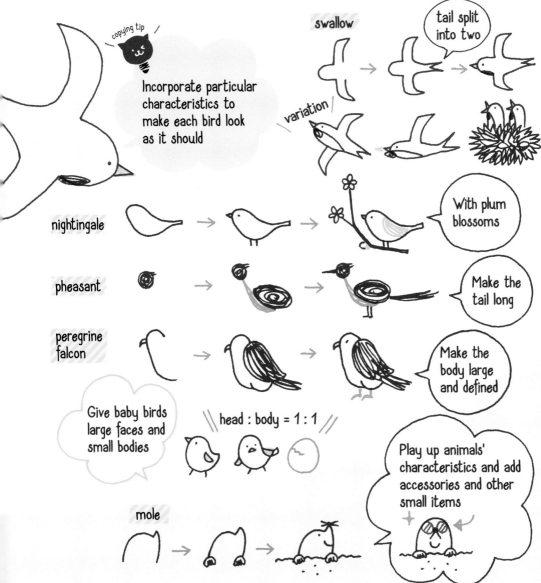

copying tip

Incorporate particular characteristics to make each bird look as it should

swallow

tail split into two

variation

With plum blossoms

nightingale

pheasant

Make the tail long

peregrine falcon

Make the body large and defined

Give baby birds large faces and small bodies

head : body = 1 : 1

Play up animals' characteristics and add accessories and other small items

mole

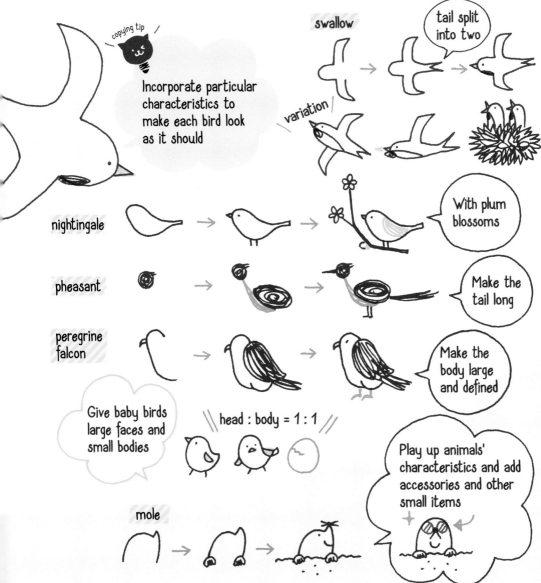

40

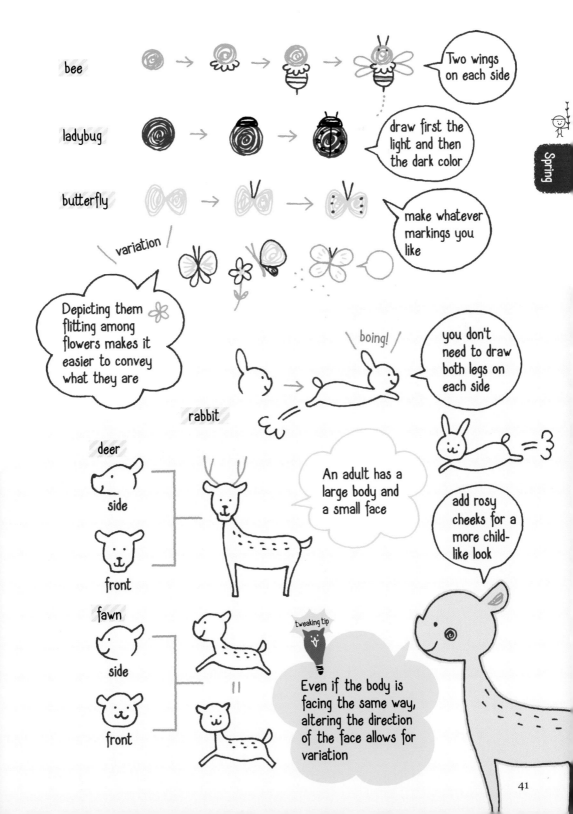

bee

Two wings on each side

ladybug

draw first the light and then the dark color

butterfly

make whatever markings you like

variation

Depicting them flitting among flowers makes it easier to convey what they are

rabbit

boing!

you don't need to draw both legs on each side

deer

side

front

An adult has a large body and a small face

add rosy cheeks for a more child-like look

fawn

side

front

tweaking tip

Even if the body is facing the same way, altering the direction of the face allows for variation

Spring

41

In Japan, spring means the Doll Festival and Children's Day

The spotlight is on Japanese kids in these two spring events, but cute kids and dolls can be added to any kid-related event at a school or daycare center.

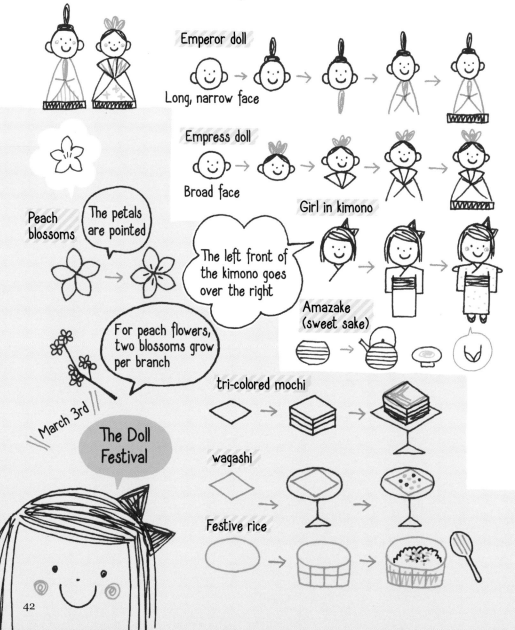

Emperor doll

Long, narrow face

Empress doll

Broad face

Girl in kimono

The left front of the kimono goes over the right

Amazake (sweet sake)

Peach blossoms

The petals are pointed

For peach flowers, two blossoms grow per branch

March 3rd

The Doll Festival

tri-colored mochi

wagashi

Festive rice

Carp banners

Boy in traditional dress

Male traditional dress is a haori jacket and hakama pants

Make different sizes and colors

For both boys and girls, the kimono crosses left over right.

Kintaro

hatchet

Golden Week

Iris

Three petals above and three below

Iris leaves for bathing

May 5th

oak-leaf-wrapped mochi

sweet sticky rice

Children's Day or the Boys' Festival

helmet

NO. 16

Level ★★★★☆

Pastels give spring fashions a feminine look and feel

Focus on the details to give clothes and accessories a feminine feel. Have fun creating the perfect spring outfits.

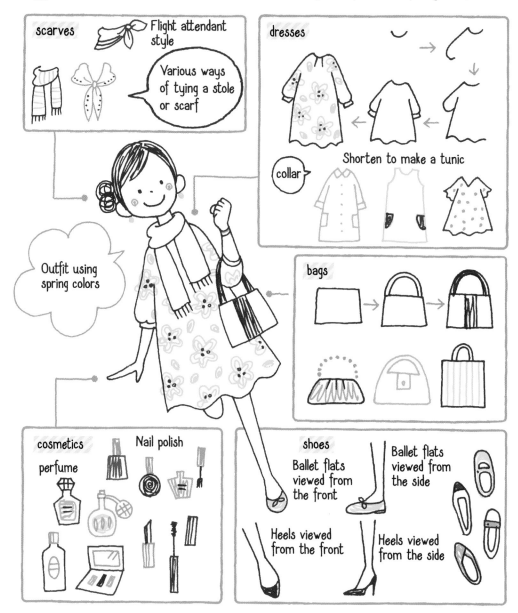

scarves

Flight attendant style

Various ways of tying a stole or scarf

dresses

Shorten to make a tunic

collar

Outfit using spring colors

bags

cosmetics

Nail polish

perfume

shoes

Ballet flats viewed from the front

Ballet flats viewed from the side

Heels viewed from the front

Heels viewed from the side

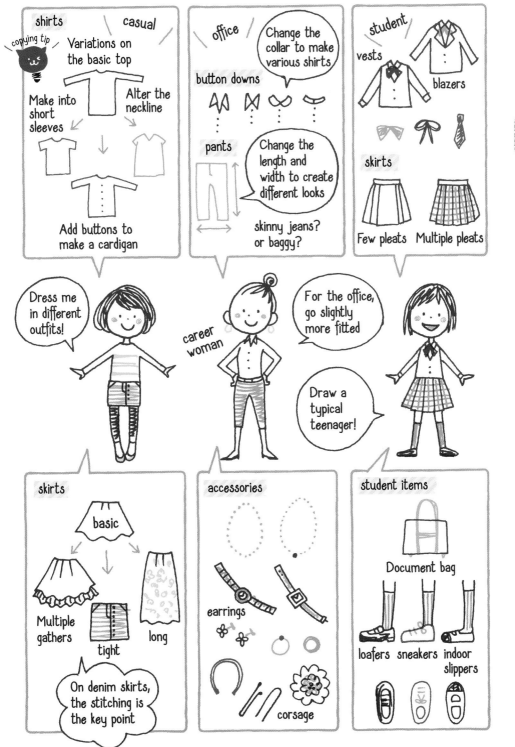

shirts · casual

copying tip

Variations on the basic top

Make into short sleeves

Alter the neckline

Add buttons to make a cardigan

office

Change the collar to make various shirts

button downs

pants

Change the length and width to create different looks

skinny jeans? or baggy?

student

vests

blazers

skirts

Few pleats · Multiple pleats

Dress me in different outfits!

career woman

For the office, go slightly more fitted

Draw a typical teenager!

skirts

basic

Multiple gathers

tight

long

On denim skirts, the stitching is the key point

accessories

earrings

corsage

student items

Document bag

loafers · sneakers · indoor slippers

45

Use seasonal produce to show the colorful foods of spring

Starting with spring vegetables, try drawing the tastes of the season.

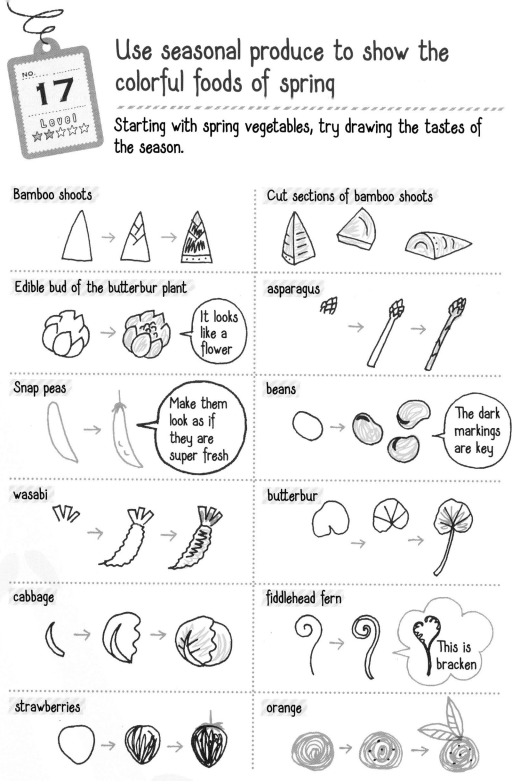

Bamboo shoots

Cut sections of bamboo shoots

Edible bud of the butterbur plant

It looks like a flower

asparagus

Snap peas

Make them look as if they are super fresh

beans

The dark markings are key

wasabi

butterbur

cabbage

fiddlehead fern

This is bracken

strawberries

orange

tuna

The striped pattern is a defining feature

mackerel

the mouth is pointed

sea bream

Zigzag dorsal fin

clams

Freshly opened

Burdock and miso mochi

The burdock is the key feature

dumplings

Draw it on a plate

Green tea

matcha

Cuisine

onigiri, or rice balls

Show the cross section

ham · lettuce · egg

Potato salad · tomato

Clam pasta

Spring vegetable salad

Apron in Spring colors

cafe meal

Piled onto the plate

potato

Wrapped bento box

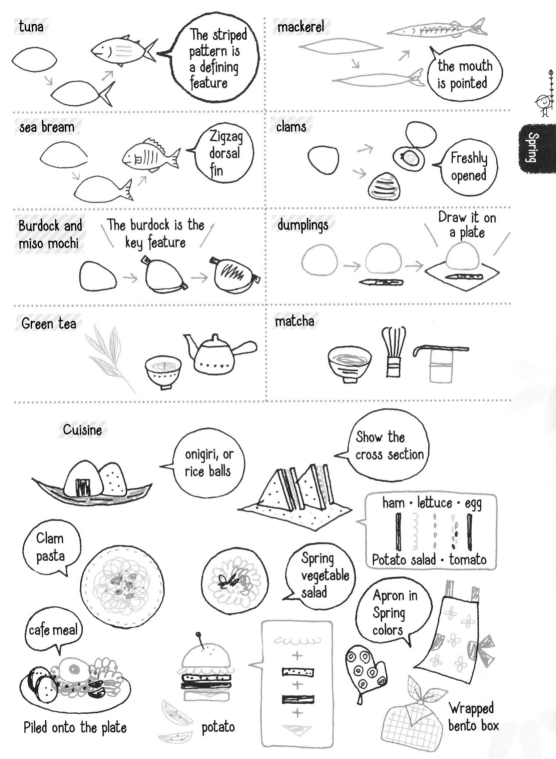

47

Use doodles for spring term activities at school

Spring brings the second half of the school year. Adorn announcements for graduation ceremonies, field trips and school club activities with illustrations that capture the spirit of celebration.

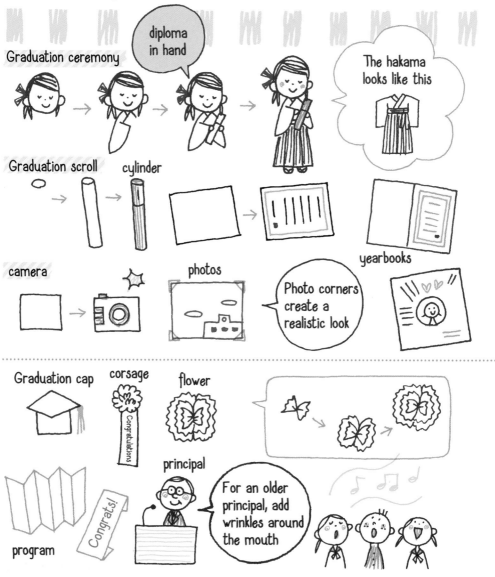

Graduation ceremony

diploma in hand

The hakama looks like this

Graduation scroll cylinder

yearbooks

camera photos

Photo corners create a realistic look

Graduation cap corsage flower

Congratulations

principal

For an older principal, add wrinkles around the mouth

Congrats!

program

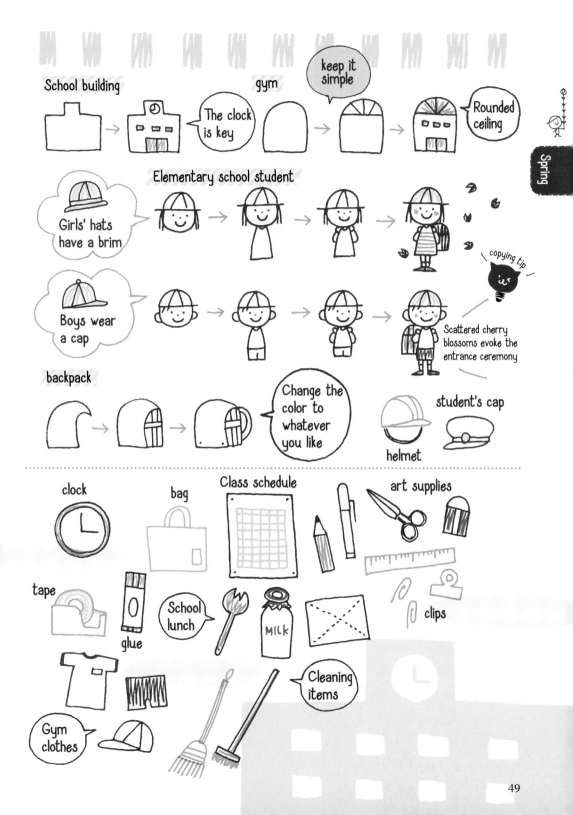

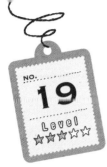

Draw your own invitations for parties and gatherings

Include foods and drinks related to the celebration and that set a festive tone. Create original invitations that will make your guests eager to attend.

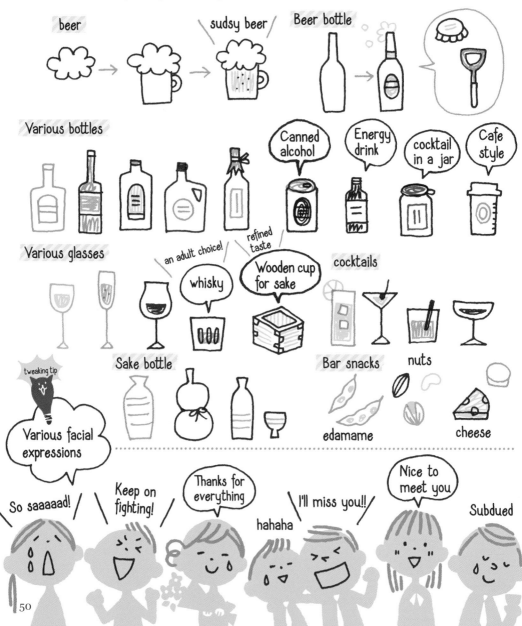

beer

sudsy beer

Beer bottle

Various bottles

Canned alcohol

Energy drink

cocktail in a jar

Cafe style

Various glasses

an adult choice!

whisky

refined taste

Wooden cup for sake

cocktails

tweaking tip

Various facial expressions

Sake bottle

Bar snacks

nuts

edamame

cheese

So saaaaad!

Keep on fighting!

Thanks for everything

hahaha

I'll miss you!!

Nice to meet you

Subdued

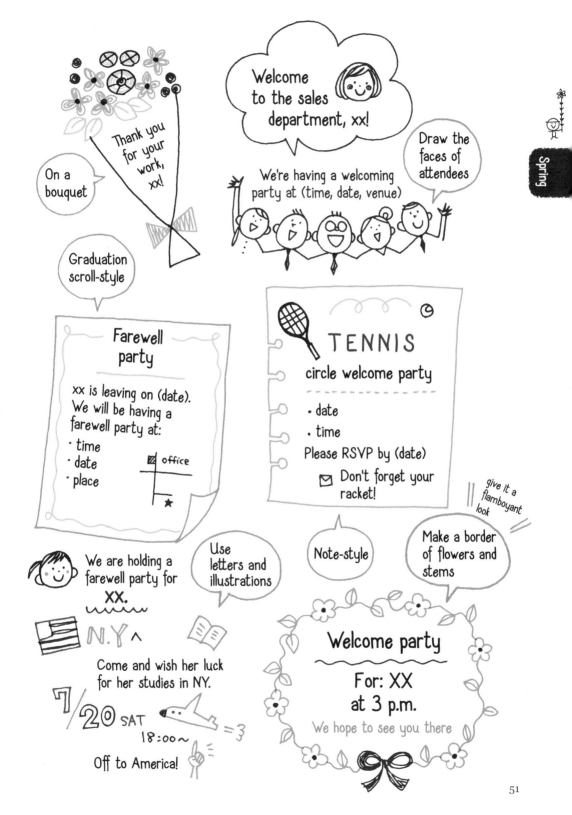

On a bouquet

Thank you for your work, xx!

Welcome to the sales department, xx!

We're having a welcoming party at (time, date, venue)

Draw the faces of attendees

Graduation scroll-style

Farewell party

xx is leaving on (date). We will be having a farewell party at:
· time
· date
· place

office
★

TENNIS

circle welcome party

· date
· time
Please RSVP by (date)

✉ Don't forget your racket!

give it a flamboyant look

We are holding a farewell party for **XX.**

Use letters and illustrations

Note-style

Make a border of flowers and stems

N.Y

Come and wish her luck for her studies in NY.

7/20 SAT
18:00~

Off to America!

Welcome party

For: XX
at 3 p.m.

We hope to see you there

Summer

Part 3

Doodles for Summer

Summer is marked by festivals, leisure activities, outdoor activities and most of all fun! Vivid colors work best to capture the spirit of the season. Like the blasts and bursts of fireworks in the night sky, you want your colors and designs to pop!

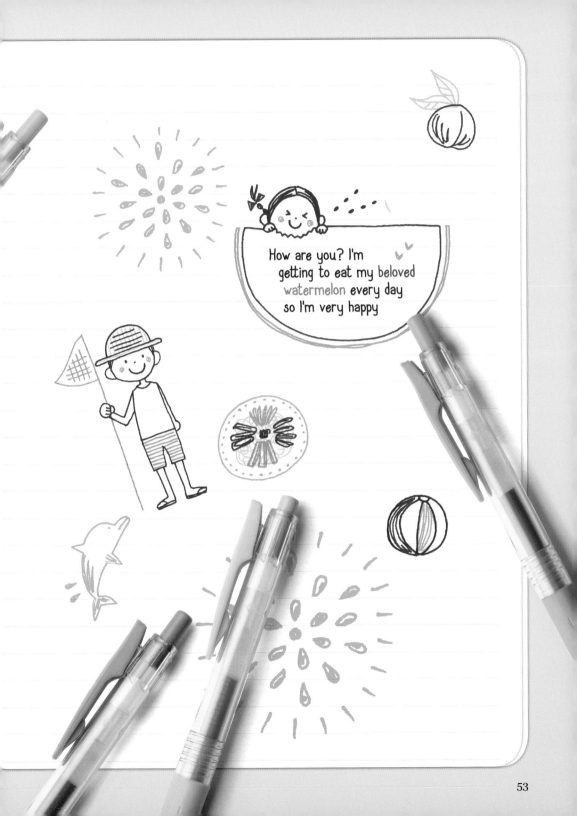

How are you? I'm
getting to eat my beloved
watermelon every day
so I'm very happy

53

Use illustrations to customize white shirts and garments

Summer is the time to wear white. Use fabric ballpoint pens to draw cute illustrations that will bring pleasure to whomever owns them.

T-shirts

Add sailor-type details to blank T-shirts to create unique, original items!

Ballpoint pens for fabric

These do not run on fabric and the color won't come out even in the wash. Make sure not to make mistakes when you draw!

Handkerchiefs and handmade fans

You can draw on gauze handkerchiefs too. Dots and other motifs that require little filling in are the easiest to do without making mistakes

NO.
20

Level
★★★☆☆

Choose doodles that capture the spirit of summer

Sweet treats, cool clothing and the colorful burst of fireworks in the night sky. These are just some of the sights to inspire your summer doodling.

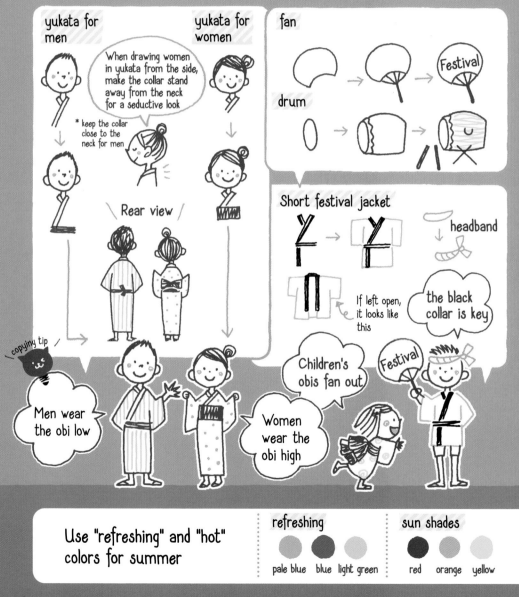

yukata for men

yukata for women

When drawing women in yukata from the side, make the collar stand away from the neck for a seductive look

* keep the collar close to the neck for men

\ Rear view /

copying tip

Men wear the obi low

Women wear the obi high

fan

Festival

drum

Short festival jacket

headband

If left open, it looks like this

the black collar is key

Children's obis fan out

Festival

Festival

Use "refreshing" and "hot" colors for summer

refreshing

pale blue blue light green

sun shades

red orange yellow

56

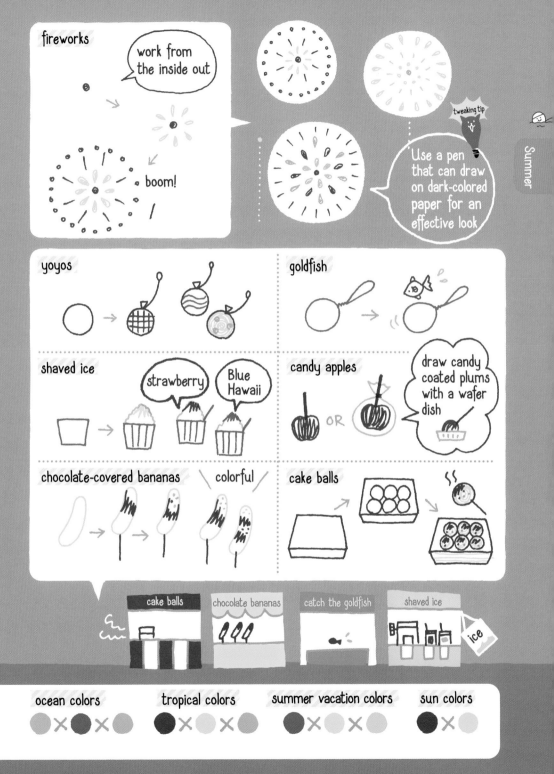

Draw items associated with fun outdoor summer activities

Swimming, boating, fishing, camping and cooking out are just some of the outdoor activities that are part of summer fun.

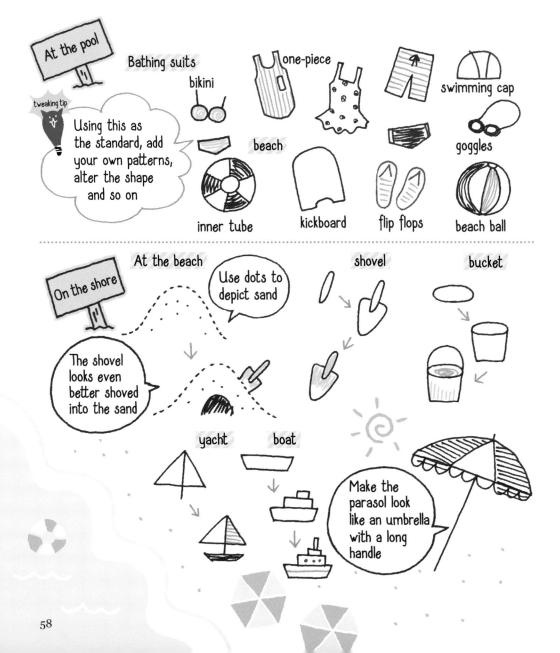

At the pool

Bathing suits
bikini
one-piece
swimming cap
goggles

tweaking tip

Using this as the standard, add your own patterns, alter the shape and so on

beach

inner tube kickboard flip flops beach ball

On the shore

At the beach

Use dots to depict sand

shovel bucket

The shovel looks even better shoved into the sand

yacht boat

Make the parasol look like an umbrella with a long handle

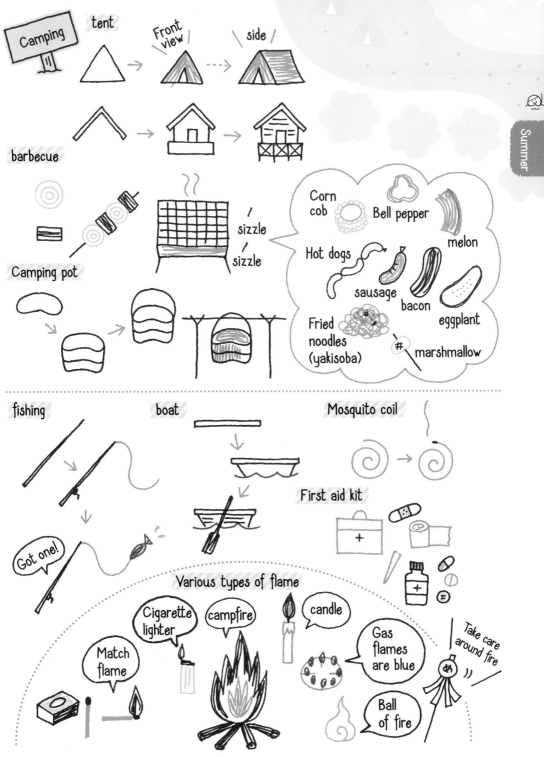

Camping

tent

Front view → side

barbecue

sizzle
sizzle

Camping pot

Corn cob Bell pepper
melon
Hot dogs
sausage bacon eggplant
Fried noodles (yakisoba) # marshmallow

fishing boat Mosquito coil

Got one!

First aid kit

Various types of flame

Match flame Cigarette lighter campfire candle

Gas flames are blue

Take care around fire

Ball of fire

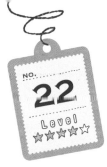

Use doodles to capture the zodiac and constellations of the summer sky

Don't forget to look to the night sky for some of your doodle inspirations. You can choose stars, planets or try the signs of the zodiac.

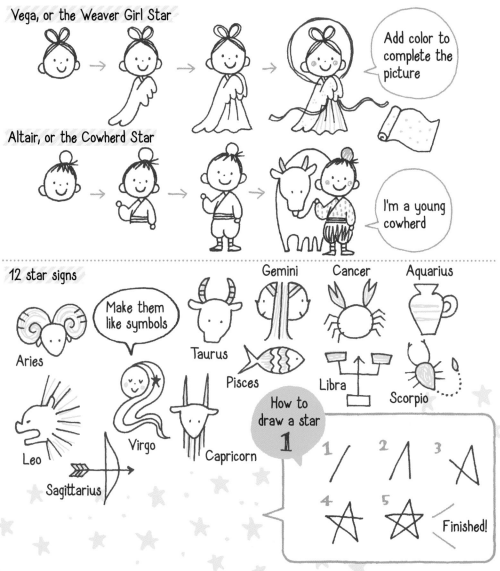

Vega, or the Weaver Girl Star

Add color to complete the picture

Altair, or the Cowherd Star

I'm a young cowherd

12 star signs

Make them like symbols

Aries

Taurus

Gemini

Cancer

Aquarius

Pisces

Libra

Scorpio

Leo

Virgo

Capricorn

How to draw a star

1

Sagittarius

1 2 3

4 5 Finished!

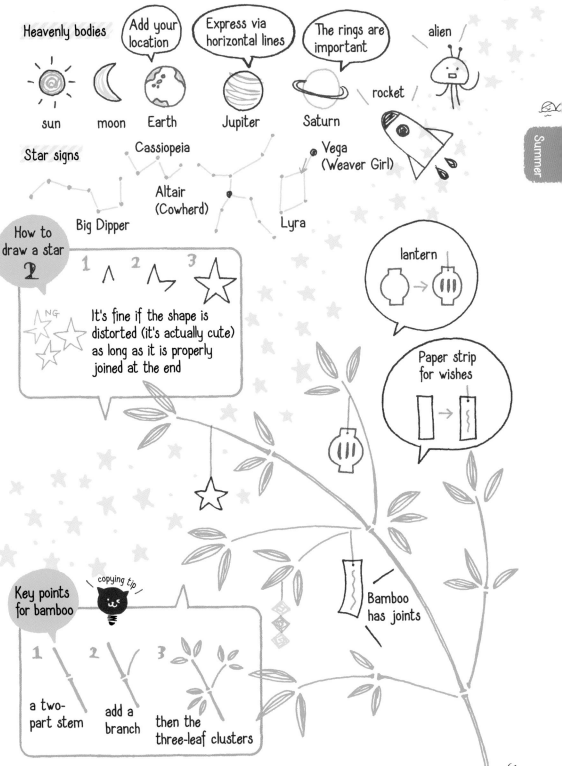

Heavenly bodies

Add your location

Express via horizontal lines

The rings are important

alien

sun moon Earth Jupiter Saturn

rocket

Star signs

Cassiopeia

Vega (Weaver Girl)

Altair (Cowherd)

Big Dipper

Lyra

How to draw a star 2

1 2 3

NG

It's fine if the shape is distorted (it's actually cute) as long as it is properly joined at the end

lantern

Paper strip for wishes

Key points for bamboo

copying tip

1 2 3

a two-part stem

add a branch

then the three-leaf clusters

Bamboo has joints

61

Capture the seasonal feel of nature to give summer creatures an authentic look

Try drawing the creatures and insects you see at the beach, in the park and on hikes during the summer. Or try coming up with your own cute summery characters.

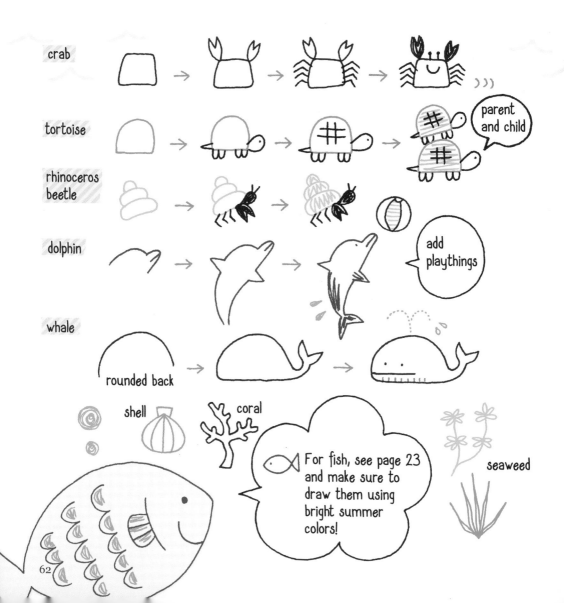

crab

tortoise

parent and child

rhinoceros beetle

dolphin

add playthings

whale

rounded back

shell

coral

For fish, see page 23 and make sure to draw them using bright summer colors!

seaweed

cicada

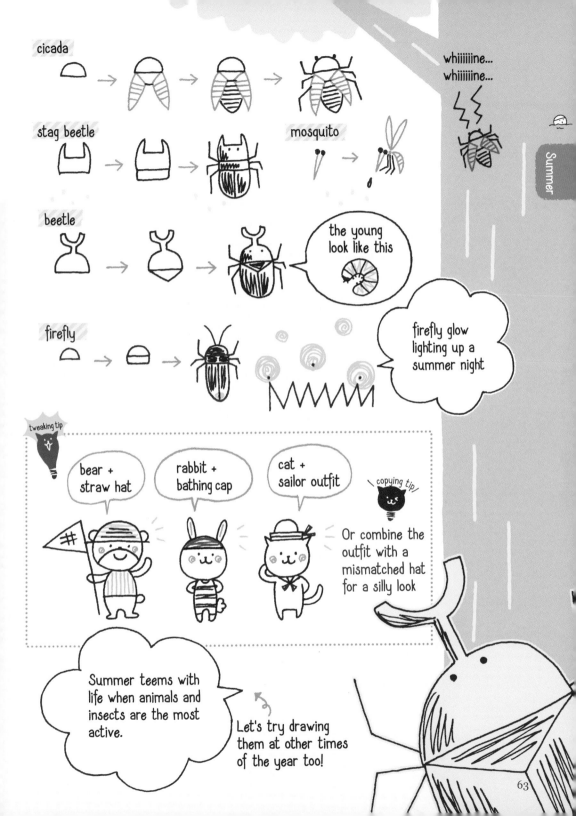

whiiiiiine...
whiiiiiine...

stag beetle

mosquito

beetle

the young look like this

firefly

firefly glow lighting up a summer night

tweaking tip

bear + straw hat

rabbit + bathing cap

cat + sailor outfit

copying tip

Or combine the outfit with a mismatched hat for a silly look

Summer teems with life when animals and insects are the most active.

Let's try drawing them at other times of the year too!

63

Use vibrant colors to capture summer plants bursting with life

Integrating primary colors into drawings of tropical and summer plants adds variety and vibrancy.

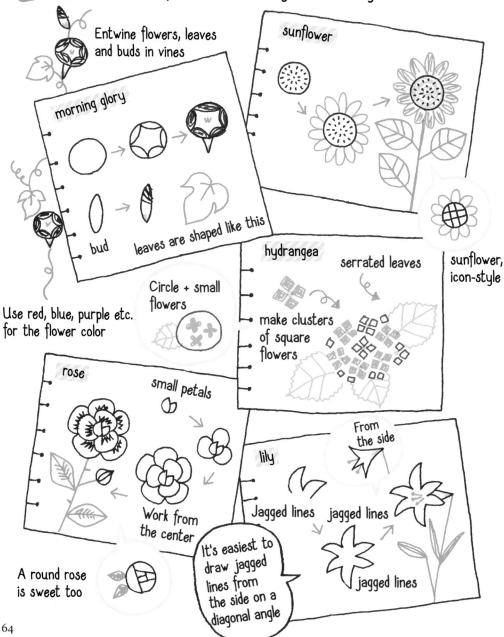

Entwine flowers, leaves and buds in vines

sunflower

morning glory

bud

leaves are shaped like this

Use red, blue, purple etc. for the flower color

Circle + small flowers

sunflower, icon-style

hydrangea

serrated leaves

make clusters of square flowers

rose

small petals

Work from the center

A round rose is sweet too

lily

From the side

Jagged lines jagged lines

It's easiest to draw jagged lines from the side on a diagonal angle

jagged lines

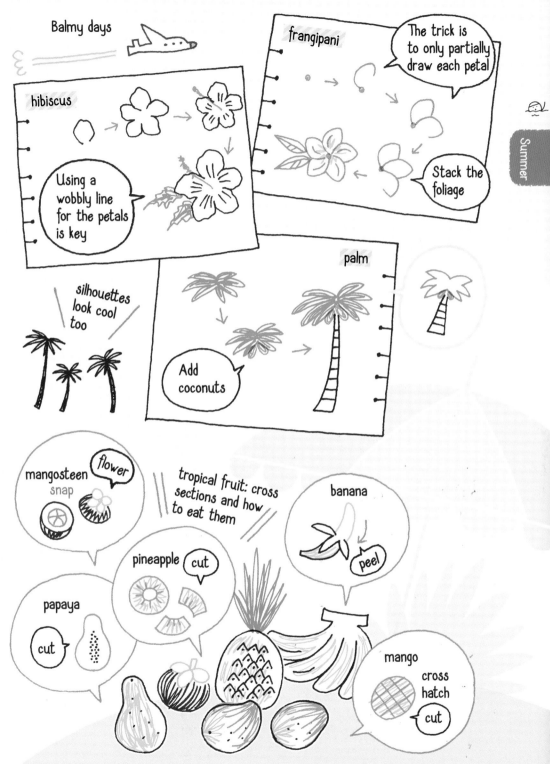

NO.
25
Level
★★★☆☆

Give your summer fashions a cool, fresh look

Cooling colors like white and pale blue add that summer feel to your cards and invitations.

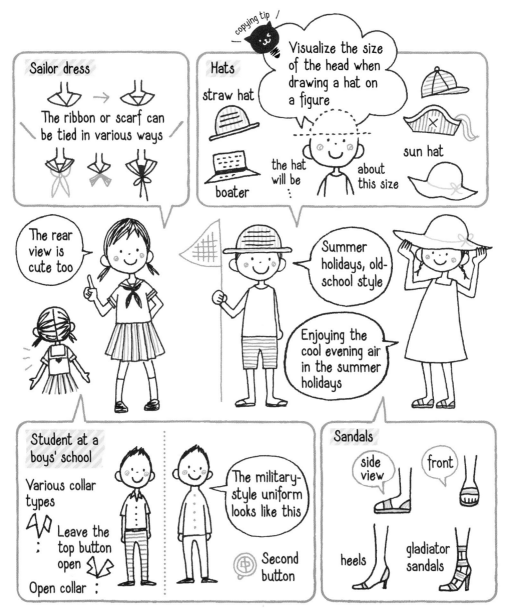

Sailor dress

The ribbon or scarf can be tied in various ways

Hats

straw hat

boater

copying tip

Visualize the size of the head when drawing a hat on a figure

the hat will be :

about this size

sun hat

The rear view is cute too

Summer holidays, old-school style

Enjoying the cool evening air in the summer holidays

Student at a boys' school

Various collar types

Leave the top button open

Open collar :

The military-style uniform looks like this

Second button

Sandals

side view

front

heels

gladiator sandals

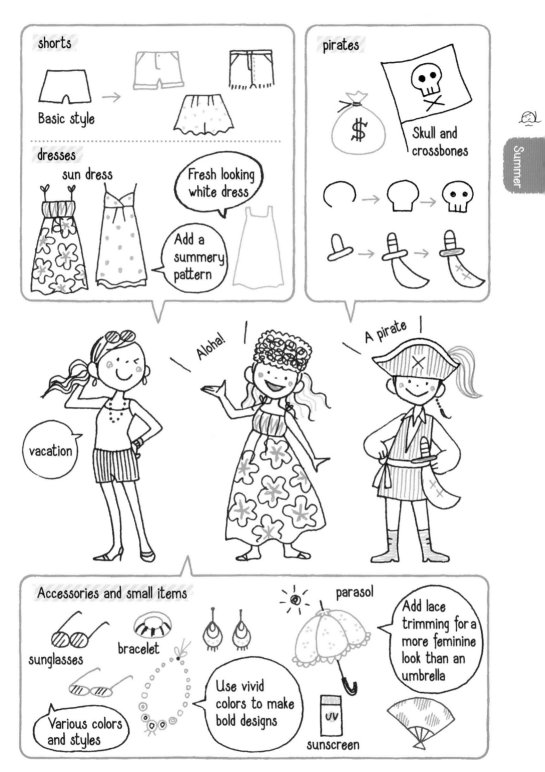

shorts

Basic style

dresses
sun dress

Fresh looking white dress

Add a summery pattern

pirates

Skull and crossbones

vacation

Aloha!

A pirate

Accessories and small items

sunglasses

bracelet

parasol

Add lace trimming for a more feminine look than an umbrella

Use vivid colors to make bold designs

Various colors and styles

UV

sunscreen

Make summer produce look ripe and flavorful

Illustrations of summer fruits and vegetables work well for message cards, diaries and hand-decorated calendars. Give fresh produce and other foods a plump and succulently juicy look.

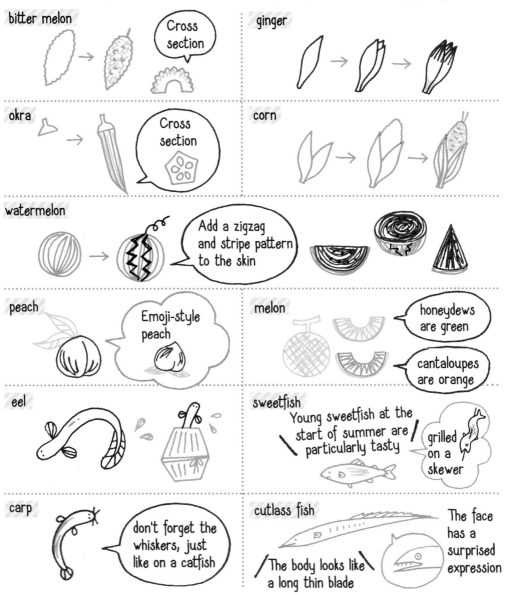

bitter melon
Cross section

ginger

okra
Cross section

corn

watermelon
Add a zigzag and stripe pattern to the skin

peach
Emoji-style peach

melon
honeydews are green
cantaloupes are orange

eel

sweetfish
Young sweetfish at the start of summer are particularly tasty
grilled on a skewer

carp
don't forget the whiskers, just like on a catfish

cutlass fish
The body looks like a long thin blade
The face has a surprised expression

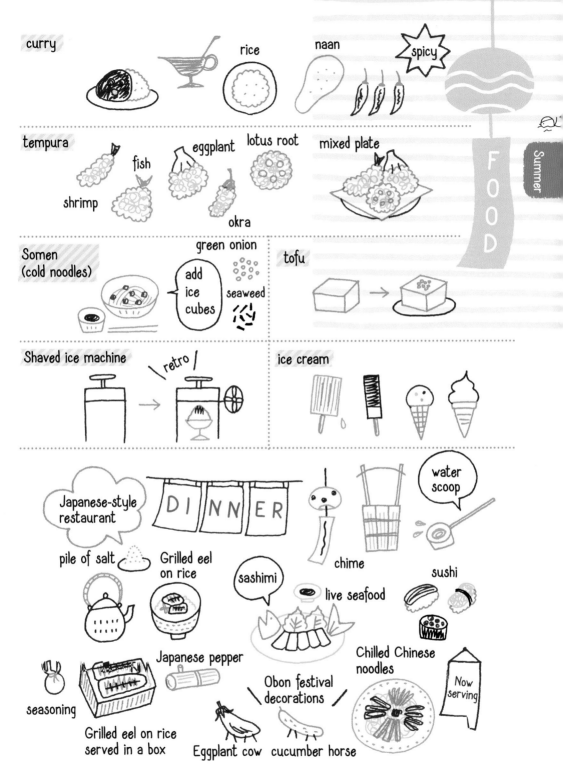

curry

rice

naan

spicy

tempura

fish

eggplant

lotus root

mixed plate

shrimp

okra

Somen (cold noodles)

green onion

add ice cubes

seaweed

tofu

Shaved ice machine

retro

ice cream

Japanese-style restaurant

DINNER

water scoop

pile of salt

Grilled eel on rice

sashimi

live seafood

chime

sushi

Japanese pepper

Chilled Chinese noodles

Now serving

seasoning

Obon festival decorations

Grilled eel on rice served in a box

Eggplant cow

cucumber horse

Use rain imagery to capture wet summer days and thunderstorms

Sometimes the summer landscape gets drenched with rain or the sky erupts with thunder and lightning. Drawing rain-related items and creatures completes the scene.

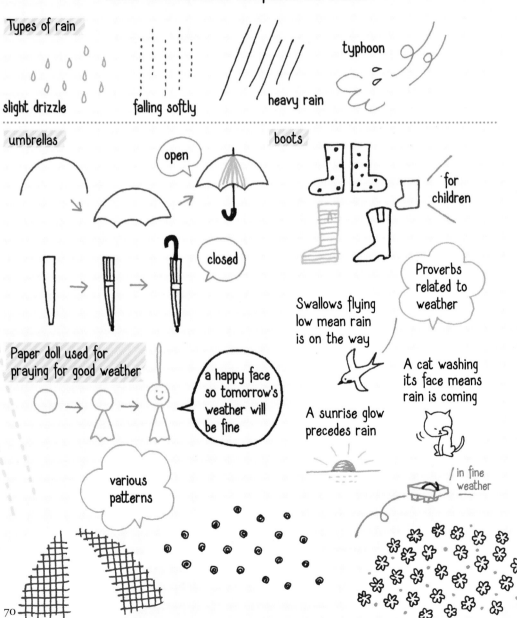

Types of rain

slight drizzle

falling softly

heavy rain

typhoon

umbrellas

open

closed

boots

for children

Proverbs related to weather

Swallows flying low mean rain is on the way

A cat washing its face means rain is coming

Paper doll used for praying for good weather

a happy face so tomorrow's weather will be fine

A sunrise glow precedes rain

in fine weather

various patterns

Child wearing raincoat

The trick to a cute look is to put the hood up

Rainy season creatures

frog

ribbit

tadpole

stylized wave

snail

slug

Pouring salt on slugs shrivels them up

tweaking tip

Bring out the feel of the season!

Frog with a leaf umbrella

Snail and hydrangea

Window with paper doll hanging in it

Rainbow in three colors

Rainbow in five colors

Rainbow in seven colors

in rain

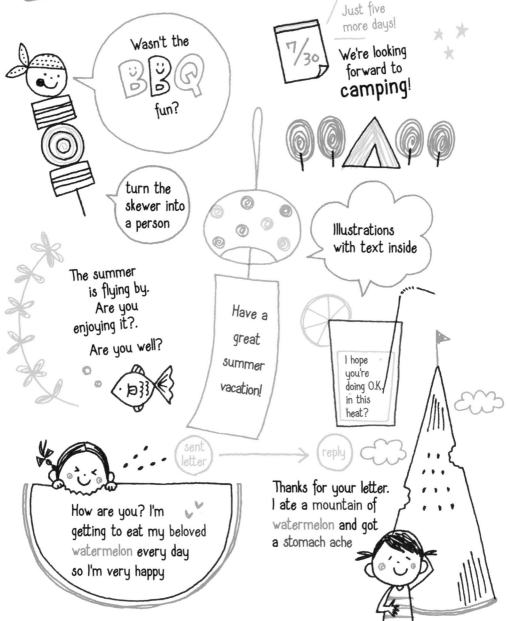

Add original illustrations to greeting cards

For greeting cards marking any occasion or time of year, use bright, cheerful colors and add illustrations that suggest the event or personalize the special message you're sending.

Wasn't the BBQ fun?

turn the skewer into a person

Just five more days!

7/30 We're looking forward to **camping**!

Illustrations with text inside

The summer is flying by. Are you enjoying it?.

Are you well?

Have a great summer vacation!

I hope you're doing O.K. in this heat?

sent letter

reply

How are you? I'm getting to eat my beloved watermelon every day so I'm very happy

Thanks for your letter. I ate a mountain of watermelon and got a stomach ache

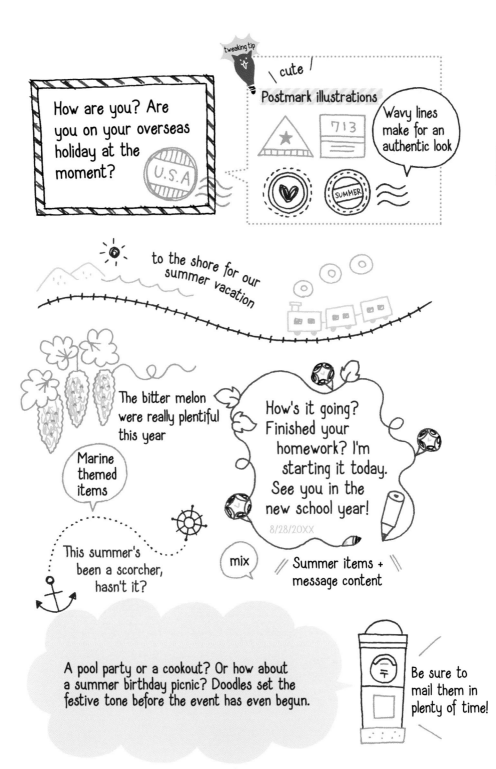

How are you? Are you on your overseas holiday at the moment?

U.S.A

tweaking tip

\ cute /

Postmark illustrations

713

SUMMER

Wavy lines make for an authentic look

to the shore for our summer vacation

The bitter melon were really plentiful this year

Marine themed items

How's it going? Finished your homework? I'm starting it today. See you in the new school year!

8/28/20XX

This summer's been a scorcher, hasn't it?

mix

Summer items + message content

A pool party or a cookout? Or how about a summer birthday picnic? Doodles set the festive tone before the event has even begun.

Be sure to mail them in plenty of time!

Dress up presents with illustrations that reflect the recipient's interests

Whether it's a present for a birthday, wedding or for the holidays, don't send it as is. Whether funny or heartfelt, choose doodles that reflect the person's interests and hobbies.

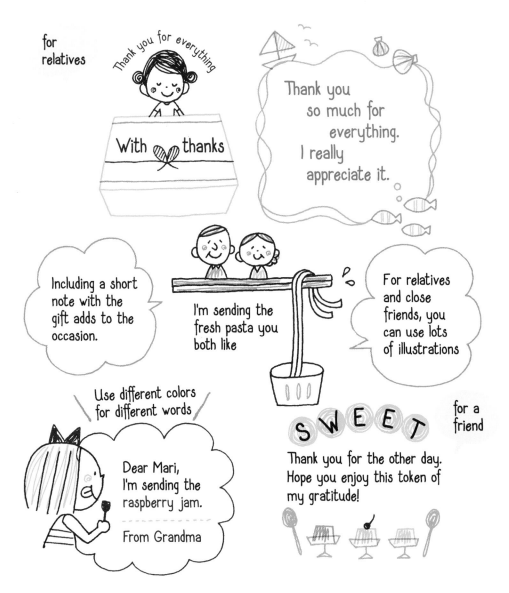

for relatives

Thank you for everything

With thanks

Thank you so much for everything. I really appreciate it.

Including a short note with the gift adds to the occasion.

I'm sending the fresh pasta you both like

For relatives and close friends, you can use lots of illustrations

Use different colors for different words

Dear Mari, I'm sending the raspberry jam.

From Grandma

SWEET

for a friend

Thank you for the other day. Hope you enjoy this token of my gratitude!

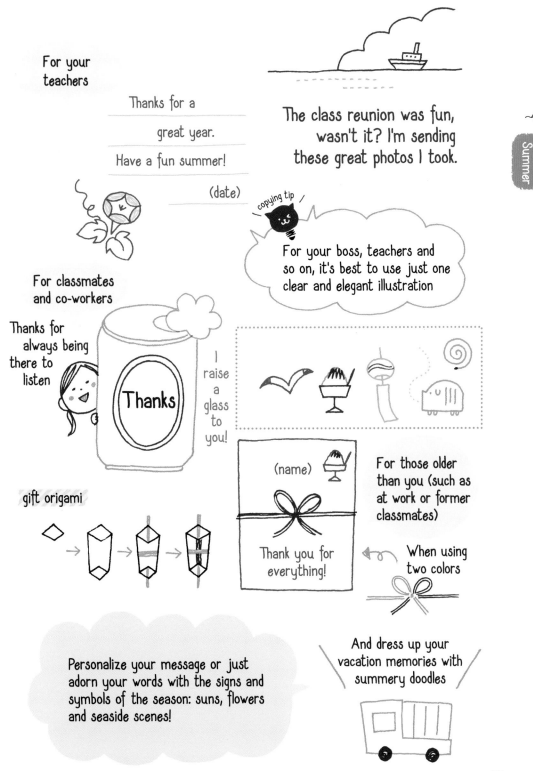

For your teachers

Thanks for a

great year.

Have a fun summer!

(date)

The class reunion was fun, wasn't it? I'm sending these great photos I took.

copying tip

For your boss, teachers and so on, it's best to use just one clear and elegant illustration

For classmates and co-workers

Thanks for always being there to listen

Thanks

I raise a glass to you!

gift origami

(name)

Thank you for everything!

For those older than you (such as at work or former classmates)

When using two colors

Personalize your message or just adorn your words with the signs and symbols of the season: suns, flowers and seaside scenes!

And dress up your vacation memories with summery doodles

fall

Part 4

Doodles for Fall

Colors such as brown, black and orange are best suited for this time when the heat of summer lifts, the air becomes crisper and the leaves start to turn and fall. Make clever use of silhouettes to suggest and express the delights and unique sensations of the season.

fall

Create a unified look for craft items

Try making decorative illustrations and patterns that complement each other!

Ballpoint pens for plastic

Use a pen that can draw on plastic to create patterns. These are bottles you'll want to take with you everywhere.

Plastic bottles

These pens can draw on plastic, glass and similar materials, but you only get one chance, as they don't rub off, so work carefully.

Book covers and bookmarks

If you could judge a book by its cover, you might actually read more of these doodled delights!

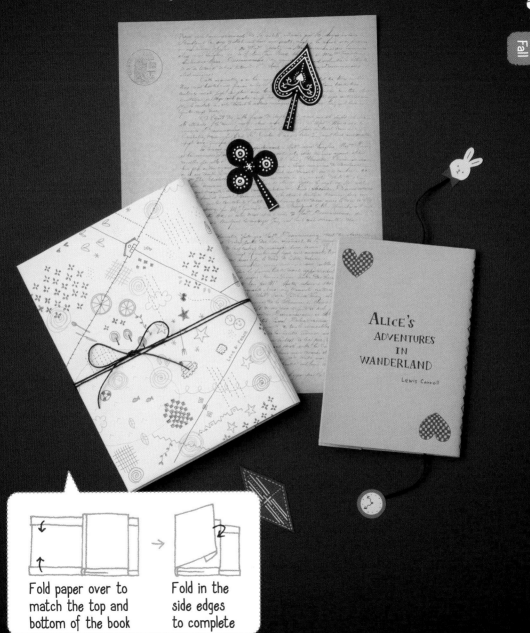

ALICE'S
ADVENTURES
IN
WANDERLAND

Lewis Carroll

Fold paper over to match the top and bottom of the book

Fold in the side edges to complete

The colors of Halloween bring your spooky doodles to life

Ghosts, ghouls and goblins appear at this time of year. Funnel a feel for the creepy and weird into your Halloween doodles, liberally leaning on that classic color combination: orange and black.

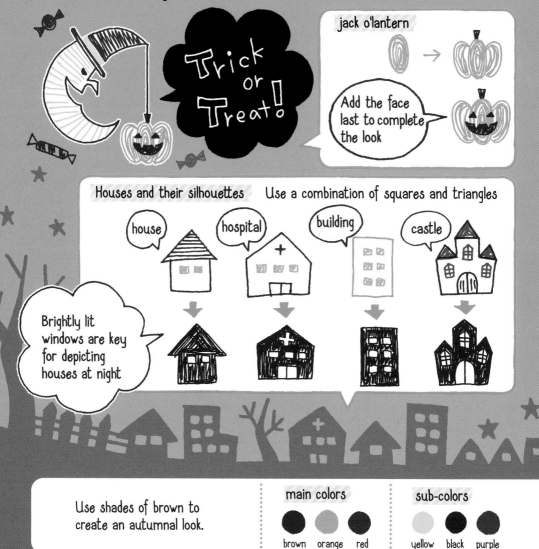

Trick or Treat!

jack o'lantern

Add the face last to complete the look

Houses and their silhouettes Use a combination of squares and triangles

house hospital building castle

Brightly lit windows are key for depicting houses at night

Use shades of brown to create an autumnal look.

main colors

brown orange red

sub-colors

yellow black purple

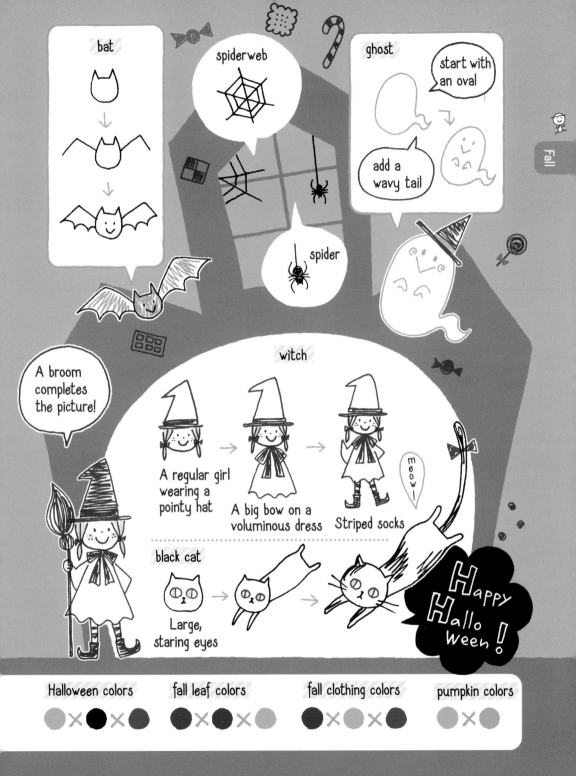

Add delicious details to fall foods

From Thanksgiving feasts to comfort foods, fall is a season for eating. Practice doodling tasty morsels to create illustrations appealing enough to make the mouth water!

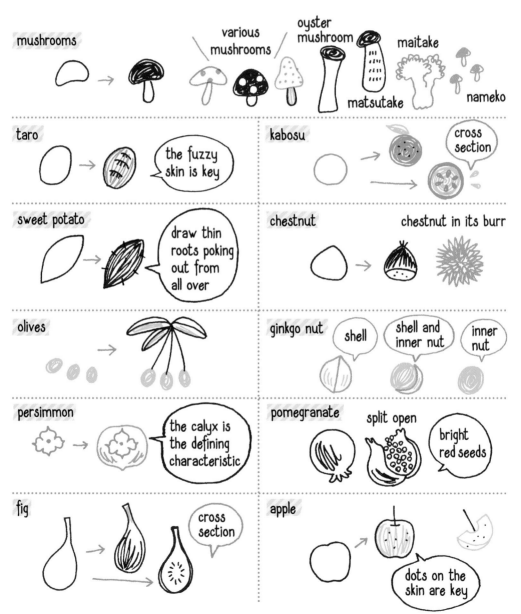

mushrooms

various mushrooms

oyster mushroom

maitake

matsutake

nameko

taro — the fuzzy skin is key

kabosu — cross section

sweet potato — draw thin roots poking out from all over

chestnut — chestnut in its burr

olives

ginkgo nut — shell — shell and inner nut — inner nut

persimmon — the calyx is the defining characteristic

pomegranate — split open — bright red seeds

fig — cross section

apple — dots on the skin are key

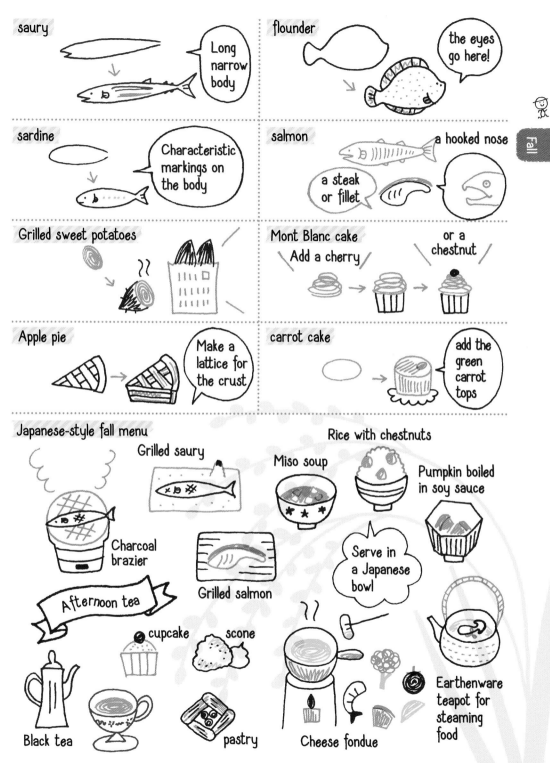

saury

Long narrow body

flounder

the eyes go here!

sardine

Characteristic markings on the body

salmon

a hooked nose

a steak or fillet

Grilled sweet potatoes

Mont Blanc cake

Add a cherry

or a chestnut

Apple pie

Make a lattice for the crust

carrot cake

add the green carrot tops

Japanese-style fall menu

Grilled saury

Rice with chestnuts

Miso soup

Pumpkin boiled in soy sauce

Charcoal brazier

Serve in a Japanese bowl

Afternoon tea

Grilled salmon

cupcake scone

Earthenware teapot for steaming food

Black tea

pastry

Cheese fondue

Focus on the details when drawing hobby items

Reading, sports, the arts, whatever your hobby is, fall is the perfect season for it. When drawing items that you're not familiar with, pay attention to the details. Your doodles will improve because of it.

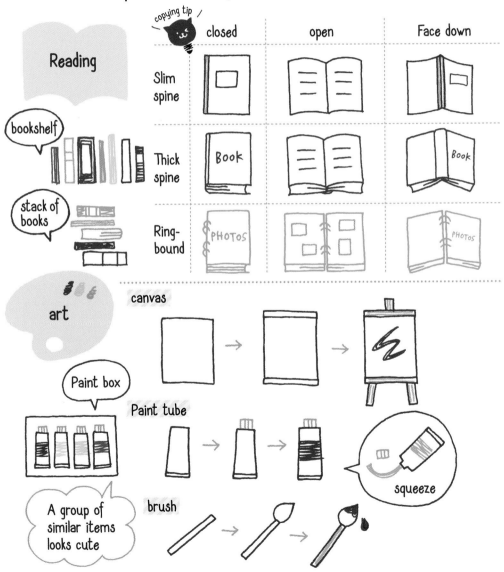

copying tip

Reading

bookshelf

stack of books

	closed	open	Face down
Slim spine			
Thick spine	Book		Book
Ring-bound	PHOTOS		PHOTOS

art

canvas

Paint box

Paint tube

squeeze

A group of similar items looks cute

brush

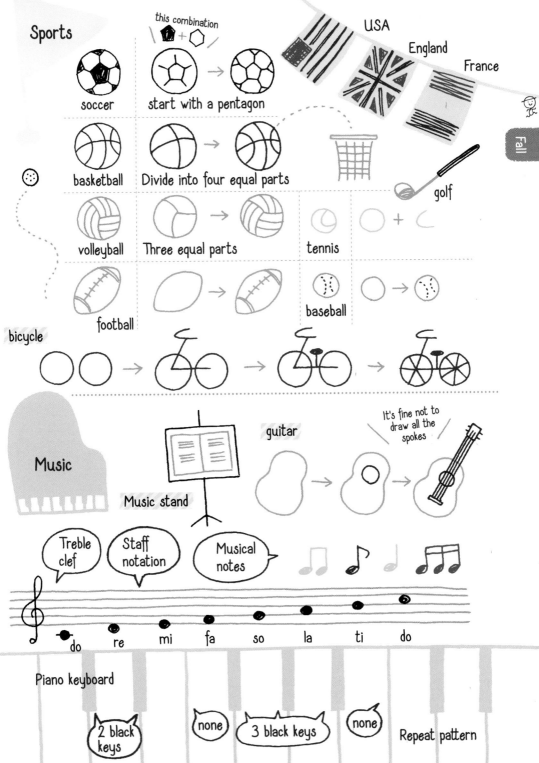

Sports

this combination 🏠 + ⬡

soccer

start with a pentagon

USA
England
France

basketball

Divide into four equal parts

golf

volleyball

Three equal parts

tennis

football

baseball

bicycle

Fall

Music

Music stand

guitar

It's fine not to draw all the spokes

Treble clef Staff notation Musical notes

do re mi fa so la ti do

Piano keyboard

2 black keys none 3 black keys none Repeat pattern

Incorporate silhouettes into your fall-themed doodles

Have you ever seen a drawing of a Halloween witch riding her broom in front of a full harvest moon? Fall is a great time to make use of silhouettes, and a great way for the new doodler to focus on shape and form.

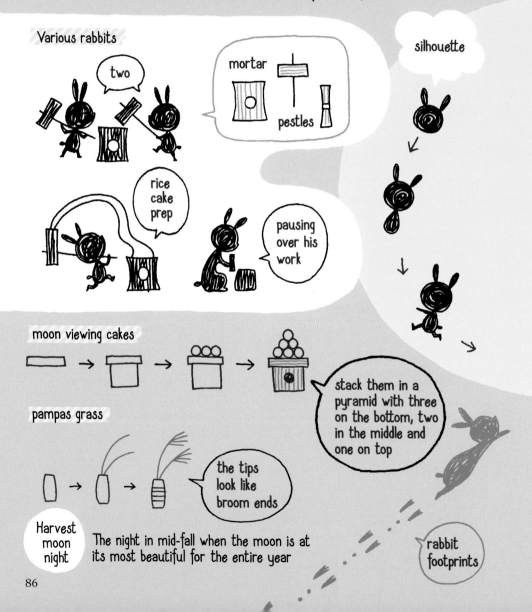

Various rabbits

two

mortar

pestles

silhouette

rice cake prep

pausing over his work

moon viewing cakes

stack them in a pyramid with three on the bottom, two in the middle and one on top

pampas grass

the tips look like broom ends

Harvest moon night

The night in mid-fall when the moon is at its most beautiful for the entire year

rabbit footprints

Moon + shadow pictures

Illustrations that look effective with the moon as a backdrop

cushion shaped body

flying squirrel

the fan is key

Princess Kaguya

protruding stomach

draw the hair blowing in the breeze

raccoon

witch

the rice cake

complete

the mortar

holding the pestle

Southern Europe

crab

Symbols of the moon around the world

Middle East

lion

South America

donkey

fall scenes

Fields of pampas grass

as an accent to the dessert table

copying tip

When drawing a blank area, enclose it first and fill in the surrounding part

Draw the house windows (page 80) in the same way

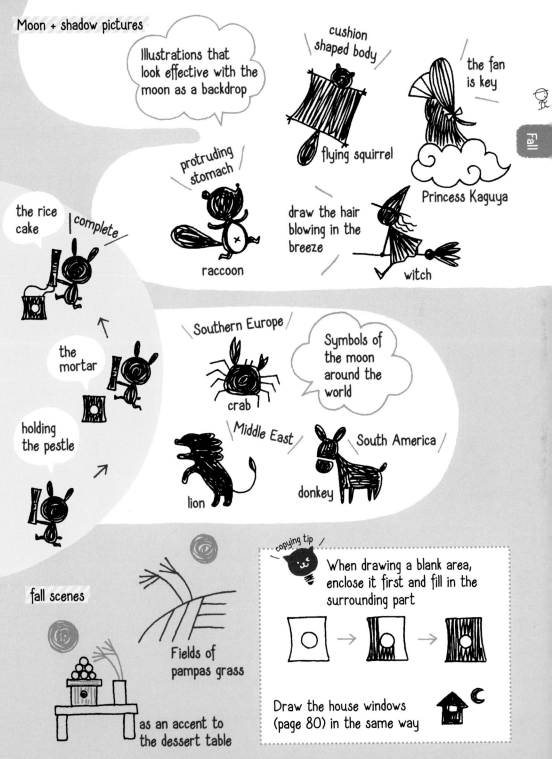

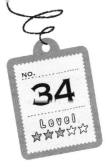

Cars are a key element in drawings of fall excursions

Going on a leaf-peeping trip to see the fantastic fall foliage? Or just off on a car trip to visit family or friends? Illustrate your scrapbook with your car-trip memories, including the places you've been and the sights you've seen.

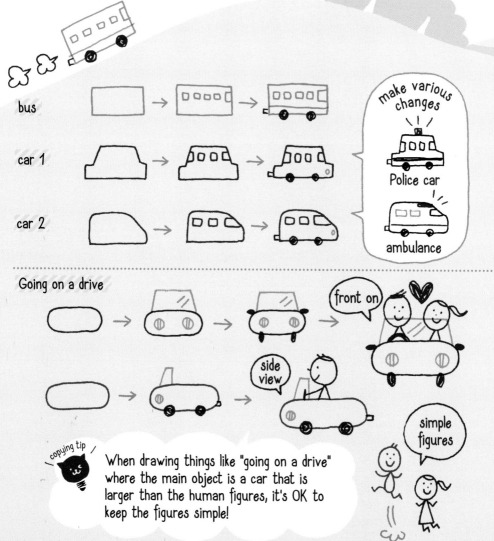

bus

car 1

car 2

make various changes

Police car

ambulance

Going on a drive

front on

side view

simple figures

copying tip

When drawing things like "going on a drive" where the main object is a car that is larger than the human figures, it's OK to keep the figures simple!

binoculars telescope

map treasure chest

compass points

N = north
S = south
W = west
E = east

modern-day explorer

backpack

Add pockets to complete!

tweaking tip

Draw faces on objects to create characters!

Miss Spoon likes Mr. Fork

Creating personalities is fun

Have you done your homework?

Adding arms and legs is cute too

Clever Mr. Fork

Miss Spoon the innocent young maiden

Professor Pencil

Make fall creatures adorably plump as they prepare for winter

Fall creatures are slightly plump as they are just about to start hibernation. Draw them together with small items that add to their adorable appearance.

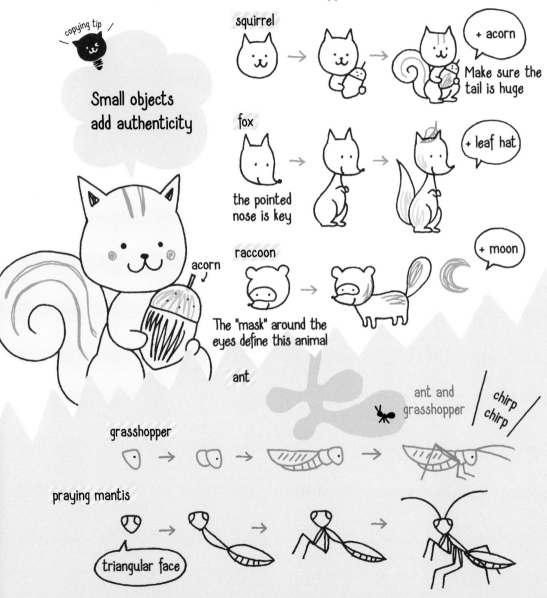

copying tip

Small objects add authenticity

squirrel

+ acorn

Make sure the tail is huge

fox

the pointed nose is key

+ leaf hat

raccoon

+ moon

The "mask" around the eyes define this animal

acorn

ant

ant and grasshopper

chirp chirp

grasshopper

praying mantis

triangular face

dragonfly

: → :⎯ → :⎯

Long thin body

Dusk + dragonflies

cocoon

→ → + a branch

bear

+ fish

add fish → → Make the body large!

+ honey is cute too

Fall

cricket

Big eyes

chirrup chirrup

◉ → ◉ → →

cicada

○ → → →

trill trill

copying tip

It's fine to draw only the legs that are visible, but depending on the angle, you may need to draw all six legs.
*The same goes for animals (4 legs), octopus (8 legs) and squid (10 legs).

91

Capture the details and transformations of fall plants

Fall foliage means an explosion of color, as red, gold and orange become the signature tones of the season. The shape of a leaf, the pointed end of a petal, be sure to pay attention to the particulars.

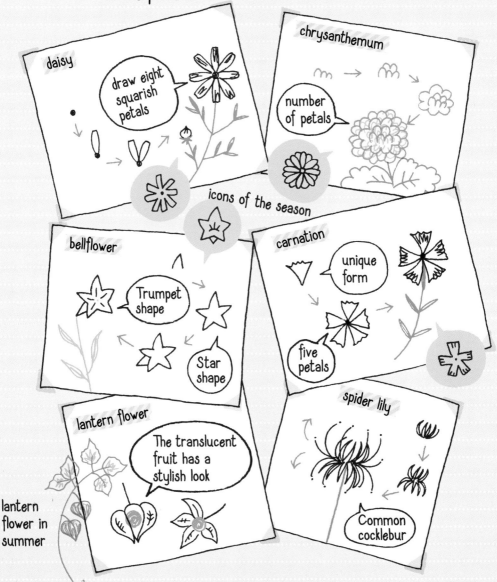

daisy
draw eight squarish petals

chrysanthemum
number of petals

icons of the season

bellflower
Trumpet shape
Star shape

carnation
unique form
five petals

lantern flower
The translucent fruit has a stylish look

spider lily
Common cocklebur

lantern flower in summer

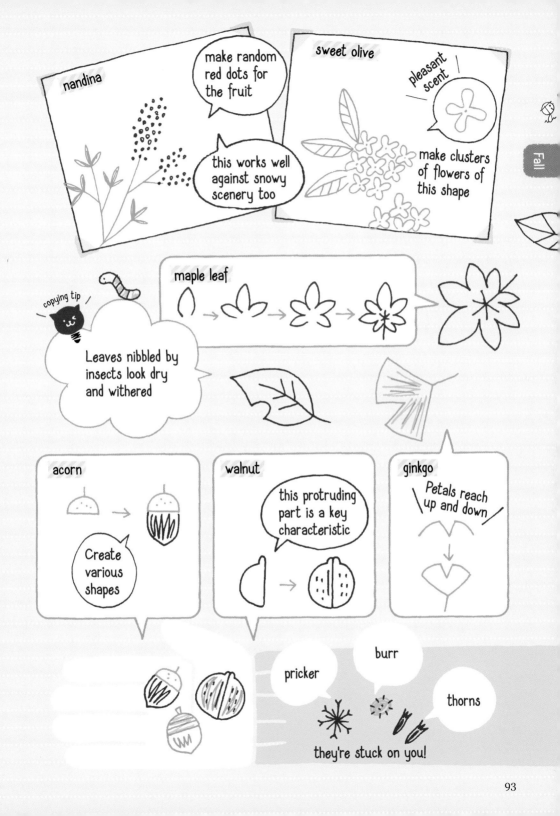

winter

Part 5

Doodles for Winter

A season packed full of holidays and events, winter kicks off with Christmas, then New Year, finally leading to the warm wishes of Valentine's Day. Make sure to give each event a different touch and a distinctive look. Using shades of off-white helps to heighten that uniquely wintery feel.

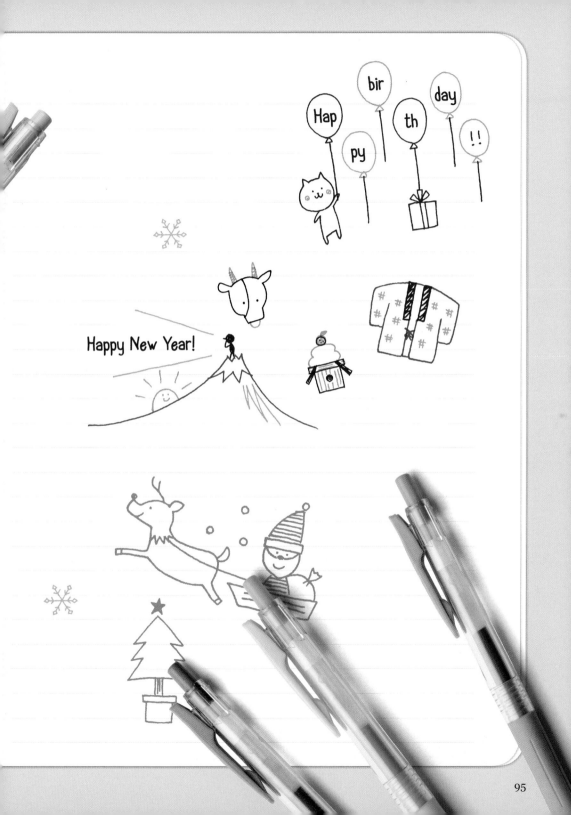

Happy New Year!

Use glitter pens to make gifts gorgeous!

winter

Try making decorative illustrations and patterns that complement each other!

Glitter pens

These pens have glitter in the ink, which flows smoothly for even distribution of color.

Puzzle

Use glitter pens to create illustrations and messages on puzzles for gifts, as they create clear, bold outlines.

Ballpoint pens for colored paper

Ballpoint pens with white ink or ink in pastel shades and other light colors are best for drawing on darker colored paper.

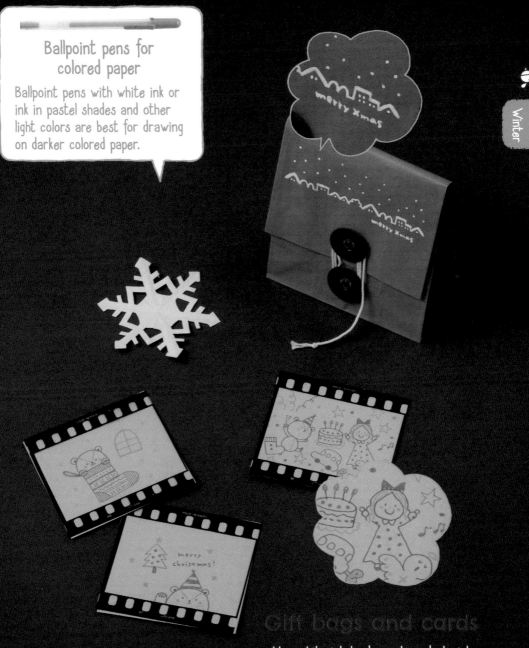

Gift bags and cards

Use white ink to decorate a dark pink bag. Lively illustrations on a card summon the holiday and seasonal spirit.

Keep outlines simple when creating illustrations for Christmas

Rather than adding too much detail to Christmas illustrations, use the object's outline as the main feature and keep it simple to highlight its defining characteristics.

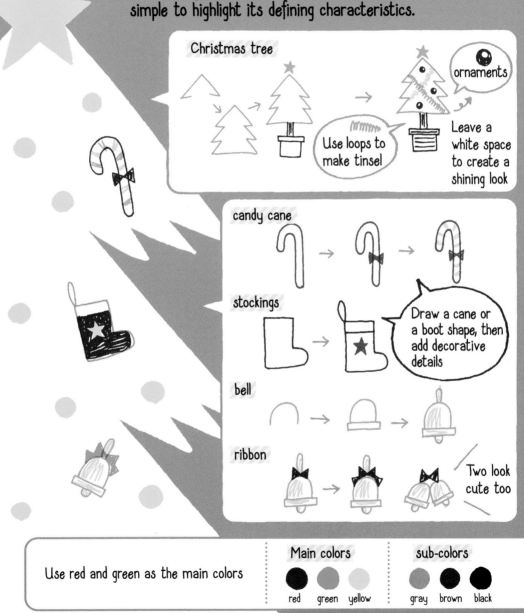

Christmas tree

Use loops to make tinsel

ornaments

Leave a white space to create a shining look

candy cane

stockings

Draw a cane or a boot shape, then add decorative details

bell

ribbon

Two look cute too

Use red and green as the main colors

Main colors			sub-colors		
red	green	yellow	gray	brown	black

98

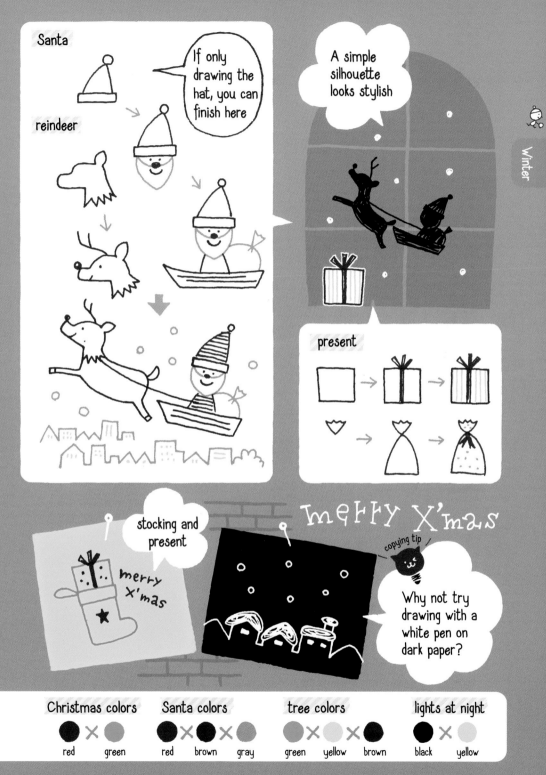

Use three main colors as the foundation for holiday cards

When creating Christmas and holiday cards, use the seasonal colors of red, green and white as the basis for your drawings. They set the right visual tone for the festivities.

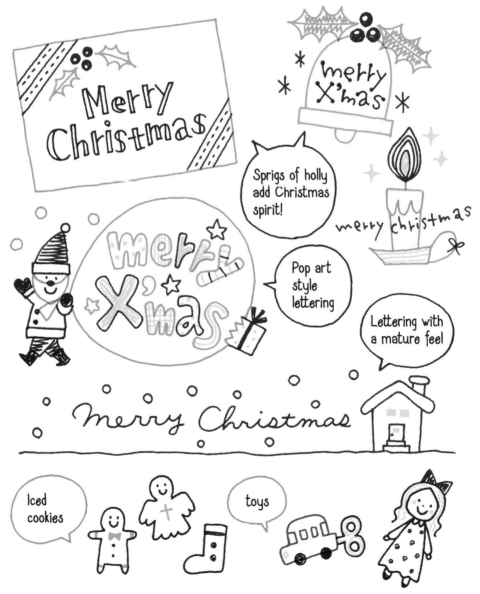

Merry Christmas

merry X'mas

merry christmas

Sprigs of holly add Christmas spirit!

Pop art style lettering

Lettering with a mature feel

merry Christmas

Iced cookies

toys

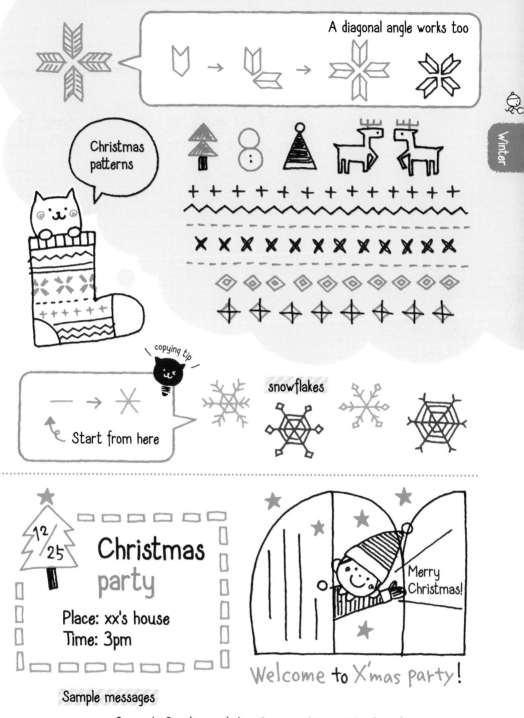

A diagonal angle works too

Christmas patterns

copying tip

snowflakes

Start from here

Christmas party

12/25

Place: xx's house
Time: 3pm

Merry Christmas!

Welcome to X'mas party!

Sample messages

Season's Greetings / I wish you a Merry Christmas!

101

Doodles for things associated with the Japanese New Year

The traditional Japanese New Year's celebration presents the amateur doodler with the ideal challenge: new items and objects to draw. Test and stretch your season-sketching skills while at the same time giving your drawings international flavor and flair.

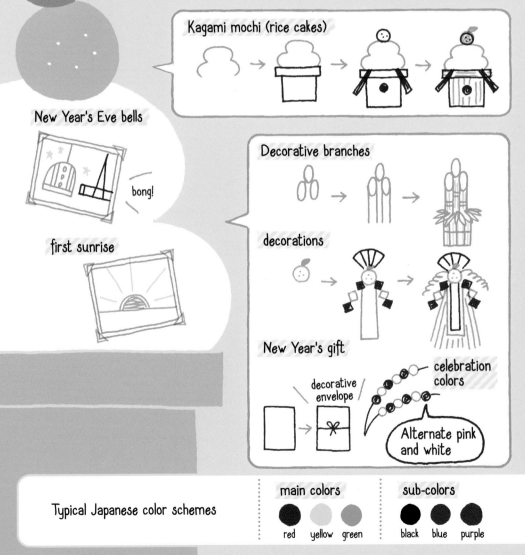

Kagami mochi (rice cakes)

New Year's Eve bells

bong!

first sunrise

Decorative branches

decorations

New Year's gift

decorative envelope

celebration colors

Alternate pink and white

Typical Japanese color schemes

main colors

red yellow green

sub-colors

black blue purple

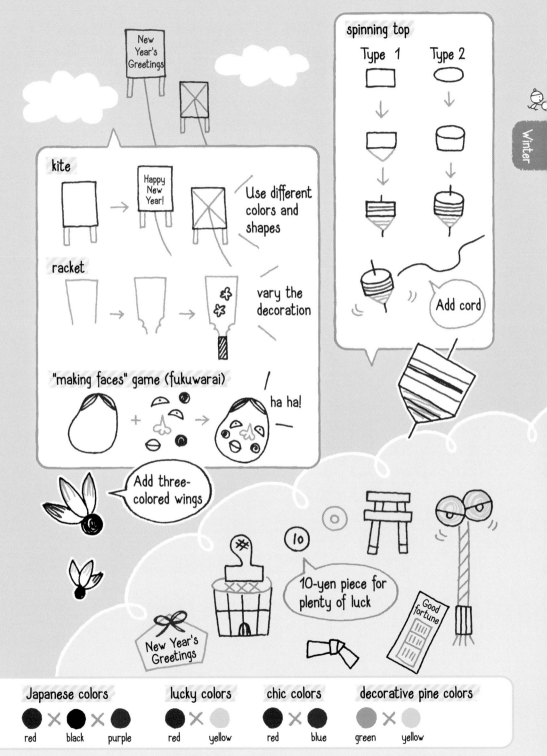

spinning top

Type 1 Type 2

Add cord

kite

Happy New Year!

Use different colors and shapes

racket

vary the decoration

"making faces" game (fukuwarai)

ha ha!

Add three-colored wings

New Year's Greetings

10

10-yen piece for plenty of luck

Good fortune

New Year's Greetings

Japanese colors	lucky colors	chic colors	decorative pine colors
red × black × purple	red × yellow	red × blue	green × yellow

Handwritten New Year's greetings add a heartfelt touch

Who says holiday cards are just for Christmas or Chanukah? Why not send a New Year's card or special turn-of-the-year greetings instead? Practice crafting heartfelt messages that will surprise and delight the recipient.

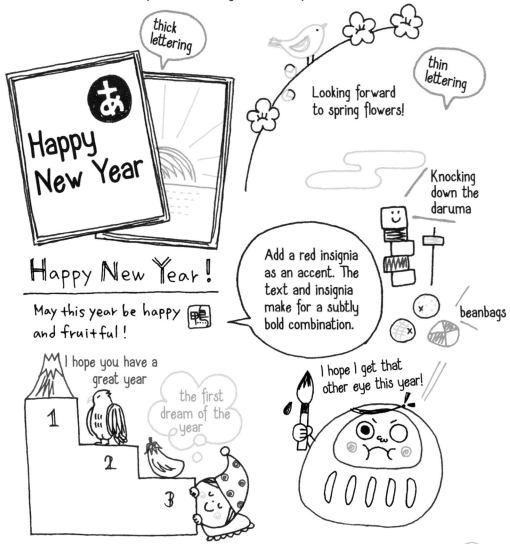

thick lettering

Looking forward to spring flowers!

thin lettering

Happy New Year

Happy New Year!

May this year be happy and fruitful!

Add a red insignia as an accent. The text and insignia make for a subtly bold combination.

Knocking down the daruma

beanbags

I hope you have a great year

1
2
3

the first dream of the year

I hope I get that other eye this year!

「Bonne Année!」 in French looks good too! Don't forget the accent over the é

zodiac animals (Icon-style)

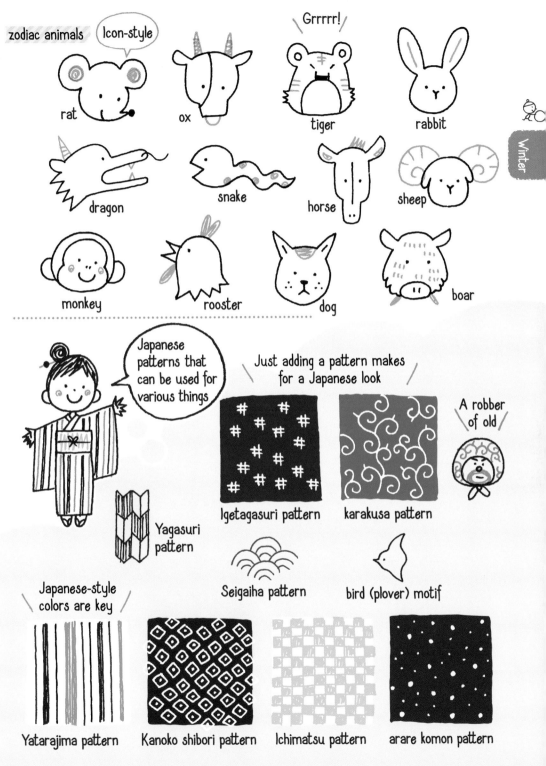

rat

ox

Grrrrr!
tiger

rabbit

Winter

dragon

snake

horse

sheep

monkey

rooster

dog

boar

Japanese patterns that can be used for various things

Just adding a pattern makes for a Japanese look

A robber of old

Igetagasuri pattern

karakusa pattern

Yagasuri pattern

Seigaiha pattern

bird (plover) motif

Japanese-style colors are key

Yatarajima pattern

Kanoko shibori pattern

Ichimatsu pattern

arare komon pattern

105

NO. **41**

Level ☆☆☆☆☆

Hand-drawn hearts perfectly convey Valentine's Day sentiments

For illustrations to accompany gifts and cards on Valentine's Day, make pink the base color and add lots of hearts to capture the warmth and affection the day celebrates.

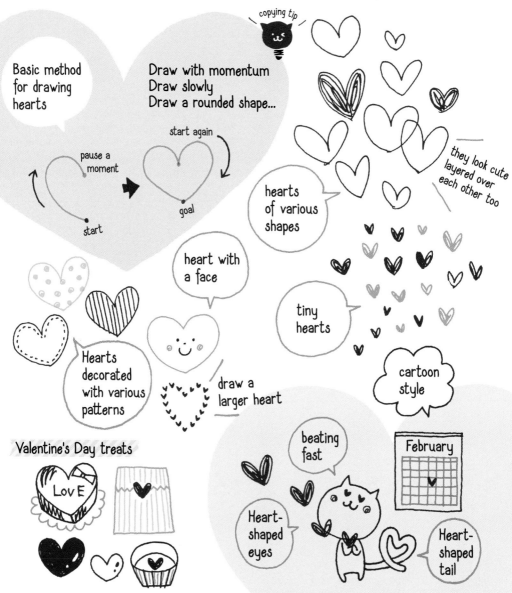

copying tip

Basic method for drawing hearts

Draw with momentum
Draw slowly
Draw a rounded shape...

pause a moment

start again

start

goal

they look cute layered over each other too

hearts of various shapes

heart with a face

tiny hearts

cartoon style

Hearts decorated with various patterns

draw a larger heart

beating fast

February

Valentine's Day treats

LovE

Heart-shaped eyes

Heart-shaped tail

106

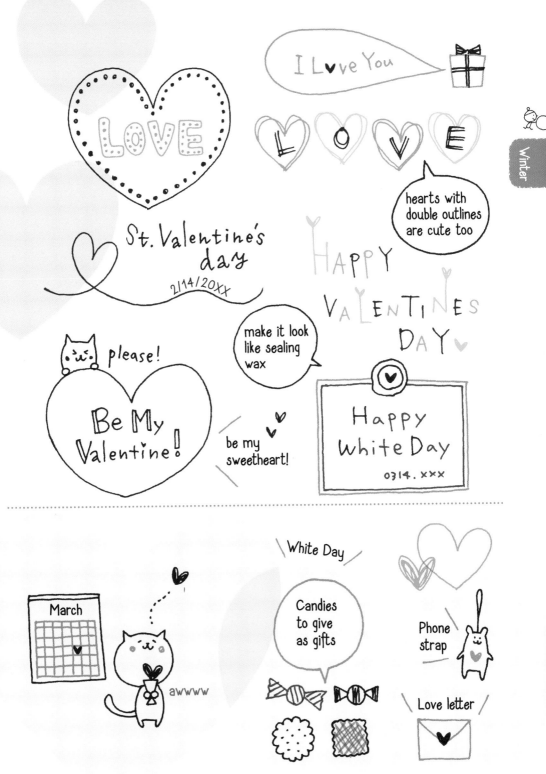

Make winter wear look fluffy and warm

When drawing winter clothing and accessories, give them a fluffy look to convey a feeling of warmth. Carefully choose your colors to capture the subdued moods of the season.

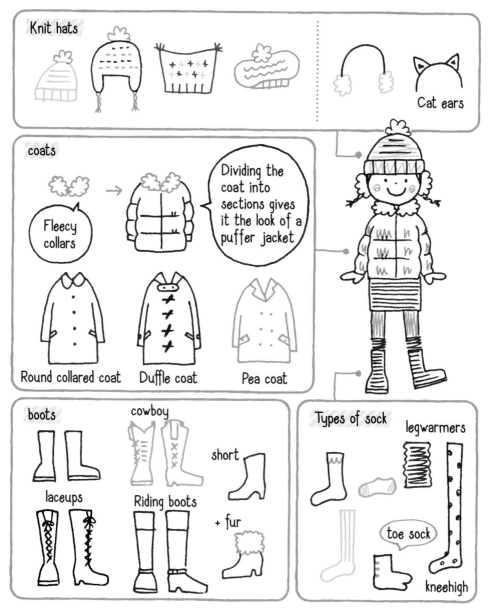

Knit hats

Cat ears

coats

Dividing the coat into sections gives it the look of a puffer jacket

Fleecy collars

Round collared coat Duffle coat Pea coat

boots cowboy

laceups Riding boots

short

+ fur

Types of sock legwarmers

toe sock

kneehigh

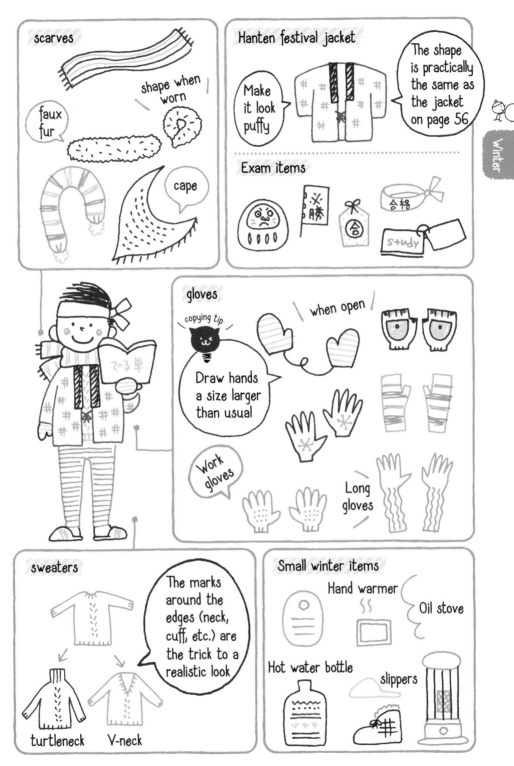

scarves

shape when worn

faux fur

cape

Hanten festival jacket

Make it look puffy

The shape is practically the same as the jacket on page 56

Exam items

gloves

copying tip
Draw hands a size larger than usual

when open

Work gloves

Long gloves

sweaters

The marks around the edges (neck, cuff, etc.) are the trick to a realistic look

turtleneck V-neck

Small winter items

Hand warmer

Oil stove

Hot water bottle

slippers

43

Level
★★★★☆

Highlight the stitching and weave when drawing knitted and woollen wear

A wool sweater, a knitted cap, a warm scarf to wrap around you on the coldest days: Add cable stitches and crocheted effects to your winter-themed doodles and messages, warm words that will help keep the cold out.

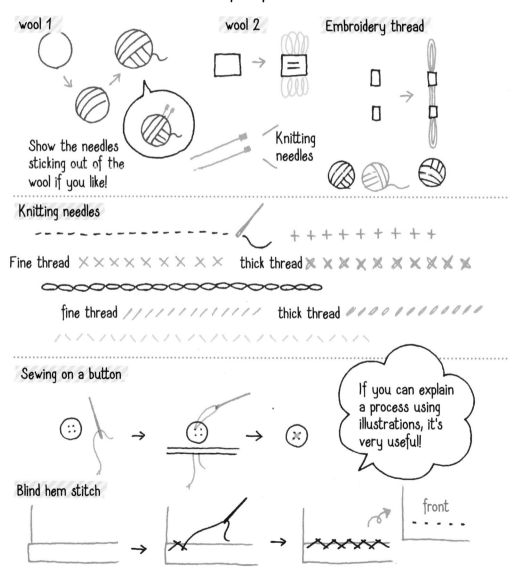

wool 1

Show the needles sticking out of the wool if you like!

wool 2

Embroidery thread

Knitting needles

Knitting needles

Fine thread × × × × × × × × × × thick thread ✕ ✕ ✕ ✕ ✕ ✕ ✕ ✕ ✕ ✕

fine thread / / / / / / / / / / / / / thick thread

Sewing on a button

If you can explain a process using illustrations, it's very useful!

Blind hem stitch

front

tweaking tip

Use the stitches on the left to create illustrations

Using stitch-like lines transforms an illustration to look like cute embroidery

Simple lines are easy to draw

Combine stitches to make a pattern

Draw letters

ABC

Draw stitches as if filling in grid lines for a clear result that closely resembles embroidery.

Various practical elements

Sewing item

belt

cord

braid

lace

Tyrolean braid

when open

Washing symbols are cute too!

Spin Cycle

dryclean only

buttons

clothespins

Safety pins

woolmark

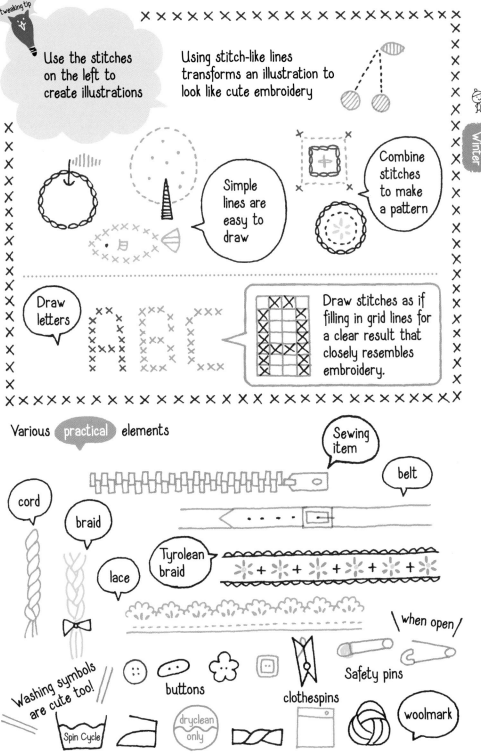

111

Level ★★★☆☆

When drawing winter sports, simplify the figures for a cleaner look

Snow means winter fun! Drawing in too much detail makes your doodle overly busy or complicated. Keep things simple by using simple figures to depict all the skating, sledding and snowball fights going on.

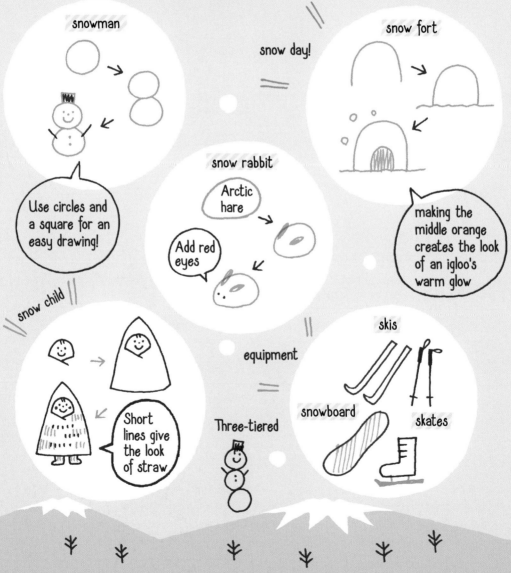

snowman

snow day!

snow fort

Use circles and a square for an easy drawing!

snow rabbit

Arctic hare

Add red eyes

making the middle orange creates the look of an igloo's warm glow

snow child

Short lines give the look of straw

equipment

Three-tiered

skis

snowboard

skates

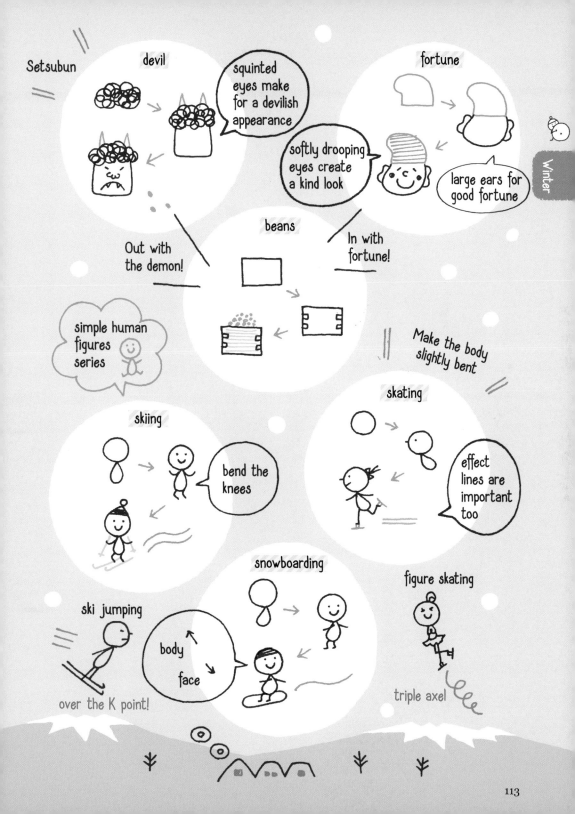

45

Level
★★★☆☆

Make use of outlines to draw cute winter creatures

When drawing fuzzy, fluffy and furry winter creatures, make use of the outline to create adorable forms. Rather than just using black, try using blues, grays and browns.

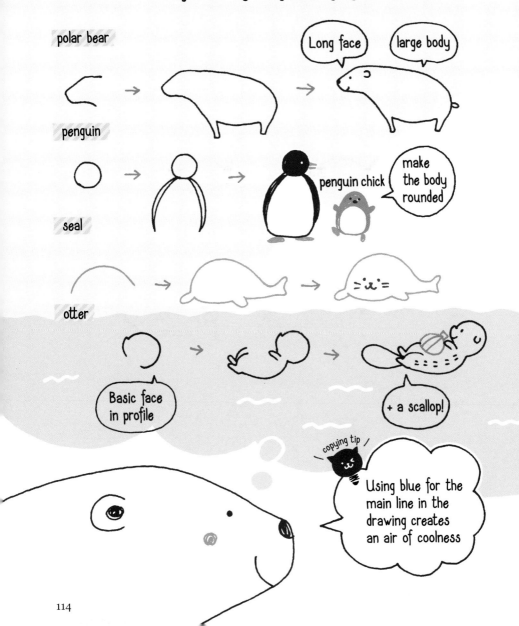

polar bear

Long face

large body

penguin

penguin chick

make the body rounded

seal

otter

Basic face in profile

+ a scallop!

copying tip

Using blue for the main line in the drawing creates an air of coolness

monkey

black-and-white monkey

Don't forget to add the short tail.

Note the similarities in their body shapes

cat

cat basking in sunshine

crane

long neck

The red marking on the head is the distinctive feature

swan

the tail curves up

goose

this bird is lucky as it delivers good news

wild goose

It takes this form as a family crest

It appears on playing cards too

You could also apply the technique of using the color of the animal as the main palette in the illustration

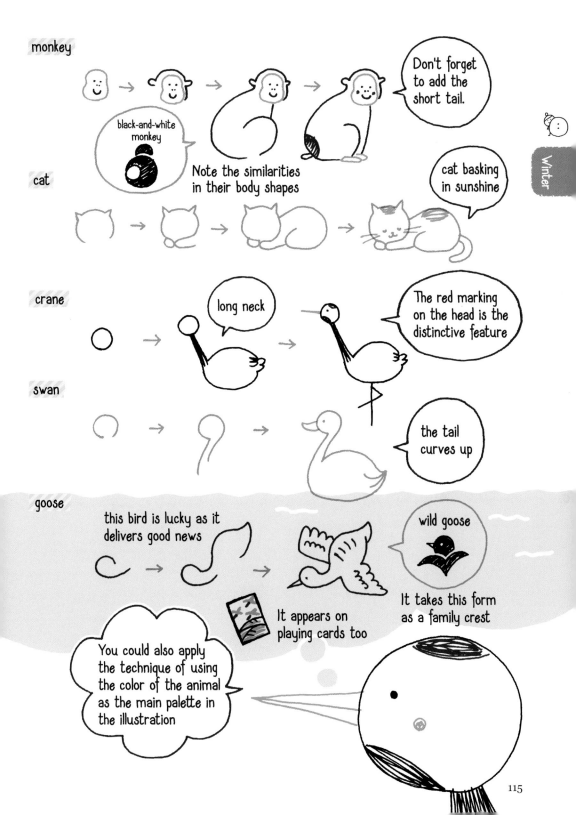

Use greenery when drawing winter plants

Wreaths, poinsettias, holly and Christmas trees: Winter plants are a key part of the holiday season. Add them to cards and invitations to brighten your presentation and highlight the greening of the season.

X'mas

poinsettia

These are the flowers

cyclamen

The flowers have a distinctive form

holly

A wreath made from branches

pine cones

work from the bottom up, gradually adding layers

Add ribbon and holly to complete the doodle

A wreath of pine cones and holly

Christmas wreaths

Simple wreath

A wreath made from branches

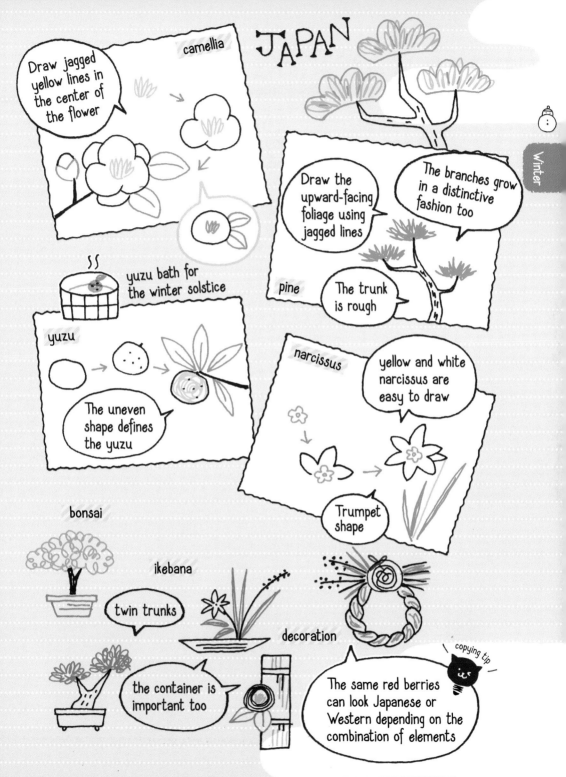

Add steam lines to capture the warmth of winter dishes

Here are some warm wintery treats from Asia and the West. Take note of their characteristics and capture their steamy fresh-made comforts.

chicken

Who gets the drumstick?

soup

The steam is important

jelly roll

gratin

Western dishes

shrimp

\ Pointed face /

Long body with split tail

oysters

Add color and internal details for authenticity

\ delicious! /

oden stew

seasonal ingredients

egg

Flour paste cake

Change the contents to make a winter hotpot

konnyaku

daikon radish

tofu pouch

New Year's dishes

fish paste

plump shape

seaweed

rolled omelette

black beans

Change the contents as you like

See page 37 for drawing the bento box

See page 37 for drawing the bento box

New Year's soup

Round bowl

Japanese meal

arrowhead

Chinese cabbage

leek

turnip

Puffer fish

pouting lips

plump it up

fish-shaped pancake

Red bean soup

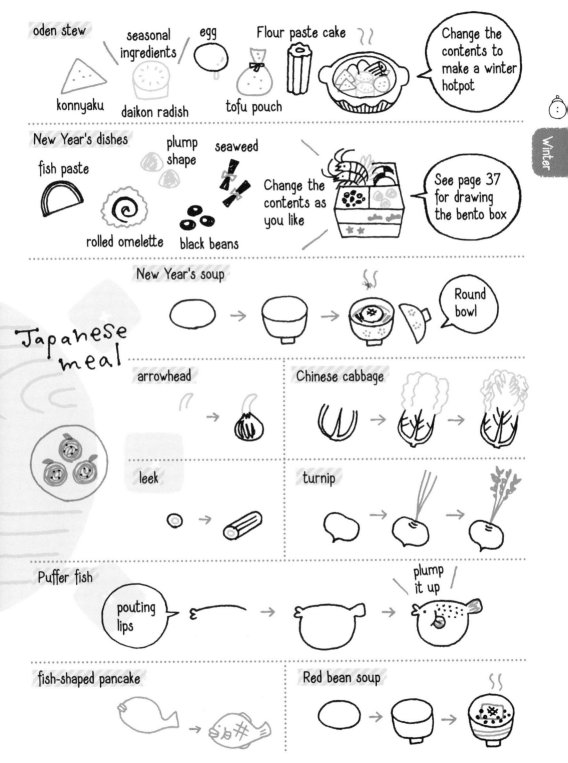

Add heartfelt illustrations and messages to New Year's greeting cards

For New Year's cards, gifts and party favors, express from the heart your appreciation for the happenings of the past year and greetings for the year to come.

New Year's presents

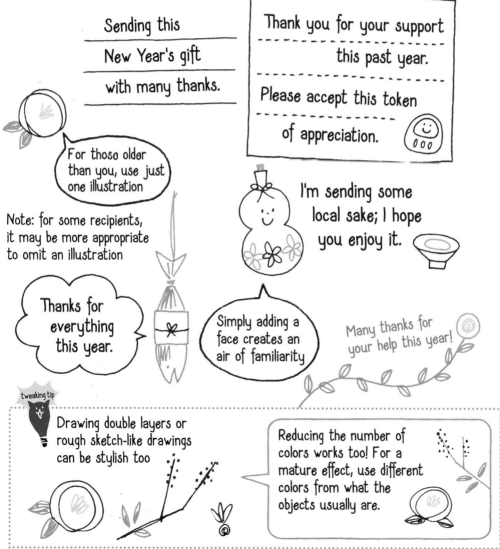

Sending this

New Year's gift

with many thanks.

Thank you for your support
this past year.

Please accept this token
of appreciation.

For those older than you, use just one illustration

Note: for some recipients, it may be more appropriate to omit an illustration

I'm sending some local sake; I hope you enjoy it.

Thanks for everything this year.

Simply adding a face creates an air of familiarity

Many thanks for your help this year!

tweaking tip

Drawing double layers or rough sketch-like drawings can be stylish too

Reducing the number of colors works too! For a mature effect, use different colors from what the objects usually are.

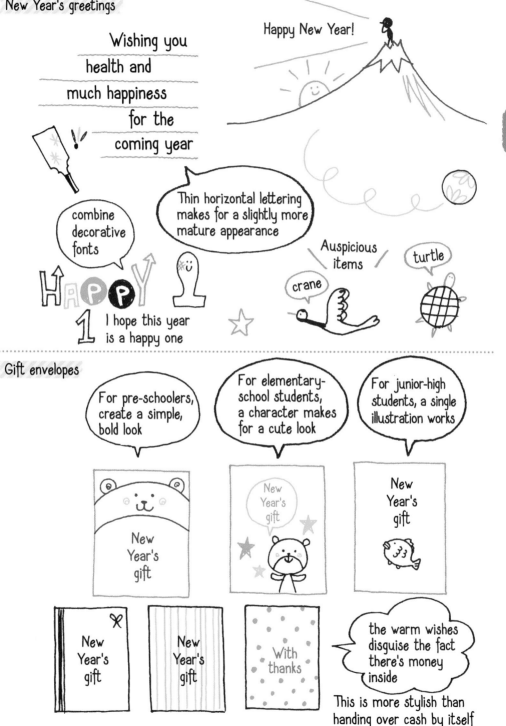

Wishing you
health and
much happiness
for the
coming year

Happy New Year!

combine decorative fonts

Thin horizontal lettering makes for a slightly more mature appearance

Auspicious items

turtle

crane

HAPPY

I hope this year is a happy one

Gift envelopes

For pre-schoolers, create a simple, bold look

For elementary-school students, a character makes for a cute look

For junior-high students, a single illustration works

New Year's gift

New Year's gift

New Year's gift

New Year's gift

New Year's gift

With thanks

the warm wishes disguise the fact there's money inside

This is more stylish than handing over cash by itself

Winter

Send your congratulations in handmade illustrated birthday card

For birthday illustrations, make sure the colors you choose for your doodle capture the spirit of celebration.

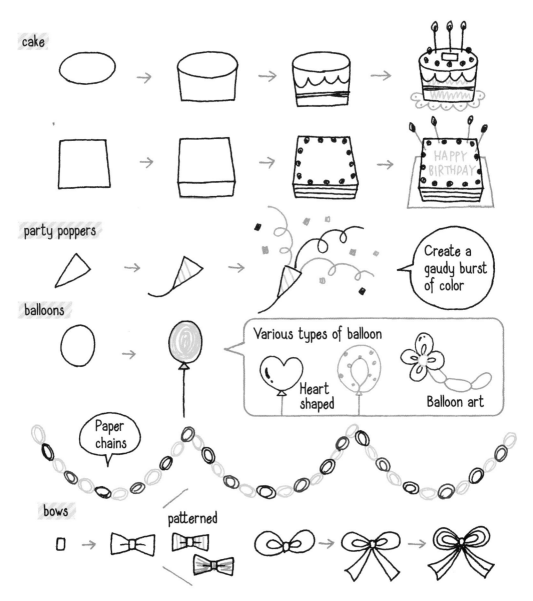

cake

party poppers

Create a gaudy burst of color

balloons

Various types of balloon

Heart shaped

Balloon art

Paper chains

bows

patterned

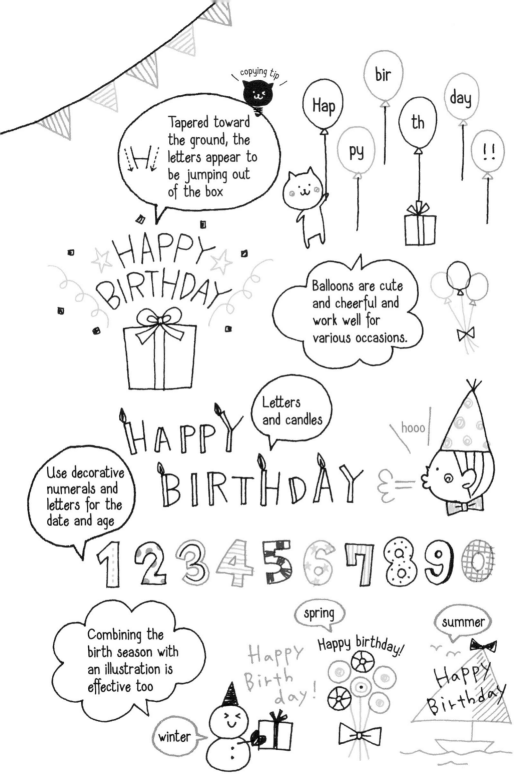

copying tip

Tapered toward the ground, the letters appear to be jumping out of the box

Hap
py
bir
th
day
!!

HAPPY BIRTHDAY

Balloons are cute and cheerful and work well for various occasions.

Letters and candles

HAPPY BIRTHDAY

hooo

Use decorative numerals and letters for the date and age

1 2 3 4 5 6 7 8 9 0

Combining the birth season with an illustration is effective too

spring

Happy Birth day!

Happy birthday!

summer

Happy Birthday

winter

123

Use line drawings to make events simple and easily understood

NO.
50
Level
★★★☆☆

Practice these drawings so you can add doodles to school and work events in your planner and calendar. The trick is to draw them using simple lines.

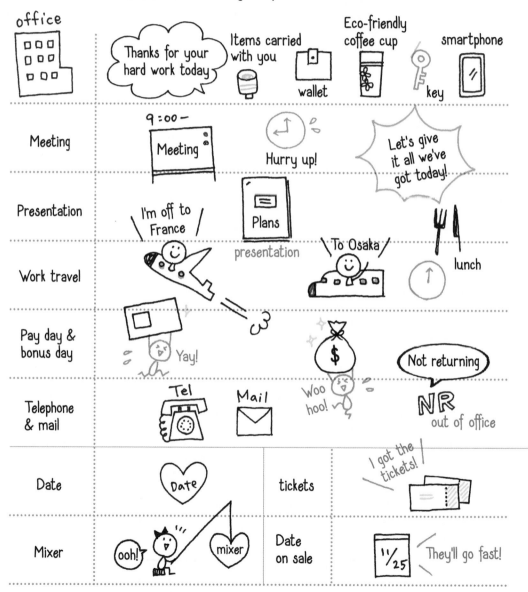

office

Thanks for your hard work today

Items carried with you

wallet

Eco-friendly coffee cup

smartphone

key

Meeting

9:00 —

Meeting

Hurry up!

Let's give it all we've got today!

Presentation

I'm off to France

Plans

presentation

To Osaka

lunch

Work travel

Pay day & bonus day

Yay!

$

Not returning

Telephone & mail

Tel

Mail

Woo hoo!

NR
out of office

Date

Date

tickets

I got the tickets!

Mixer

ooh!

mixer

Date on sale

11/25

They'll go fast!

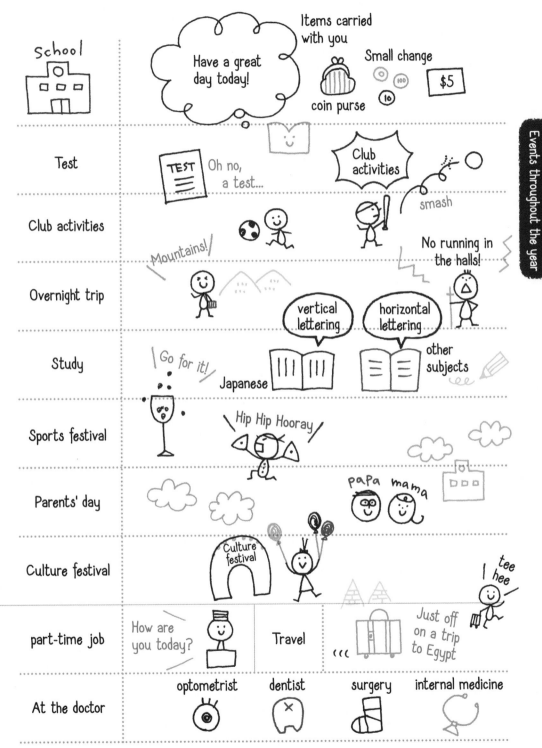

School

Test

Club activities

Overnight trip

Study

Sports festival

Parents' day

Culture festival

part-time job

At the doctor

For wedding, birth and other announcements, keep it brief

When creating invitations or announcements for weddings, births or moving into a new house, use, births or relocation, use short messages and illustrations for a concise but cute way to relay the information.

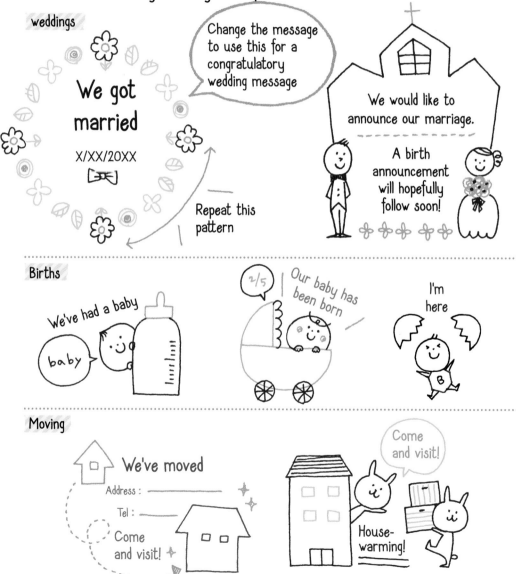

weddings

We got married

X/XX/20XX

Change the message to use this for a congratulatory wedding message

Repeat this pattern

We would like to announce our marriage.

A birth announcement will hopefully follow soon!

Births

We've had a baby

baby

2/5
Our baby has been born

I'm here

Moving

We've moved

Address :
Tel :
Come and visit!

Come and visit!

House-warming!

Other occasions

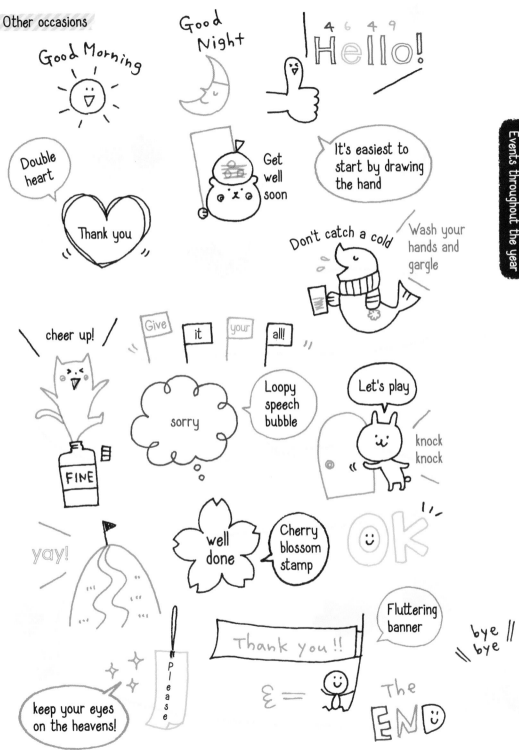

Good Morning

Good Night

4 6 4 9 Hello!

Double heart

Thank you

Get well soon

It's easiest to start by drawing the hand

Don't catch a cold

Wash your hands and gargle

cheer up!

Give it your all!

FINE

sorry

Loopy speech bubble

Let's play

knock knock

yay!

well done

Cherry blossom stamp

OK

keep your eyes on the heavens!

Please

Thank you!!

Fluttering banner

bye bye

The END

127

Author profile: Kamo

After working as a designer at an advertising production company, Kamo became a freelance illustrator, focusing on characters, books and advertisements before expanding into videos and consumer products as well. An instructor of illustration courses in Japan and internationally, Kamo is co-author of *How to Draw Almost Everything for Kids* and author of *How to Doodle Everywhere* and *How to Draw Almost Every Day: An Illustrated Sourcebook*. Visit Kamo's website at kamoco.net.

Published by Tuttle Publishing, an imprint of Periplus Editions (HK) Ltd

www.tuttlepublishing.com

BALL PEN DE KANTANI: MANESURU DAKEDE SHIKI NO PETIT KAWA ILLUST GA KAKERU HON
Copyright (c) Figinc, Kamo 2012
All rights reserved.
English translation rights arranged with MATES Universal Contents Co., Ltd. through Japan UNI Agency, Inc., Tokyo

ISBN 978-4-8053-1586-6

English Translation ©2020 Periplus Editions (HK) Ltd.

Distributed by
North America, Latin America & Europe
Tuttle Publishing
364 Innovation Drive
North Clarendon, VT 05759-9436 U.S.A.
Tel: 1 (802) 773-8930; Fax: 1 (802) 773-6993
info@tuttlepublishing.com; www.tuttlepublishing.com

Japan
Tuttle Publishing
Yaekari Building 3rd Floor
5-4-12 Osaki
Shinagawa-ku
Tokyo 141-003
Tel: (81) 3 5437-0171; Fax: (81) 3 5437-0755
sales@tuttle.co.jp; www.tuttle.co.jp

Asia Pacific
Berkeley Books Pte. Ltd.
3 Kallang Sector #04-01
Singapore 349278
Tel: (65) 67412178; Fax: (65) 67412179
inquiries@periplus.com.sg. www.tuttlepublishing.com

Printed in Malaysia 2106VP

24 23 22 21 10 9 8 7 6 5 4 3

TUTTLE PUBLISHING® is a registered trademark of Tuttle Publishing, a division of Periplus Editions (HK) Ltd.

"Books to Span the East and West"

Tuttle Publishing was founded in 1832 in the small New England town of Rutland, Vermont [USA]. Our core values remain as strong today as they were then—to publish best-in-class books which bring people together one page at a time. In 1948, we established a publishing office in Japan—and Tuttle is now a leader in publishing English-language books about the arts, languages and cultures of Asia. The world has become a much smaller place today and Asia's economic and cultural influence has grown. Yet the need for meaningful dialogue and information about this diverse region has never been greater. Over the past seven decades, Tuttle has published thousands of books on subjects ranging from martial arts and paper crafts to language learning and literature—and our talented authors, illustrators, designers and photographers have won many prestigious awards. We welcome you to explore the wealth of information available on Asia at **www.tuttlepublishing.com**.